IMAGES
of America

PINELLAS
COUNTY

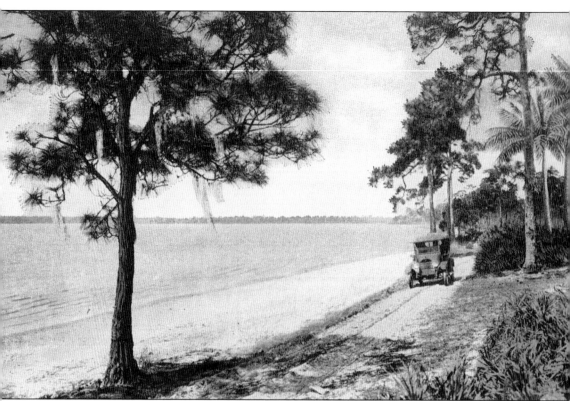

An automobile travels leisurely along the beach in Oldsmar during the 1920s.

IMAGES
of America

PINELLAS
COUNTY

A.M. de Quesada Jr. and Vincent G. Luisi

ARCADIA
PUBLISHING

Published by Arcadia Publishing
Charleston, South Carolina

Printed in the United States of America

Library of Congress Catalog Card Number: 98-86768

For all general information contact Arcadia Publishing at:
Telephone 843-853-2070
Fax 843-853-0044
E-mail sales@arcadiapublishing.com
For customer service and orders:
Toll-Free 1-888-313-2665

Visit us on the Internet at www.arcadiapublishing.com

To my father, Vincent Luisi Sr.,
a man I truly respected, admired, and loved.
He helped me obtain the things necessary to become a better person.

CONTENTS

ACKNOWLEDGMENTS

We would like to thank the following individuals and institutions that made this book possible: Dr. A.M. de Quesada; Paul Eugen Camp, Special Collections, University of South Florida; John Lindstrom, St. Petersburg Historical Museum; the Dunedin Historical Society; the Safety Harbor Museum of Regional History (SHMRH); Amy F. David, Director of Safety Harbor Museum of Regional History; Lead museum staff volunteer Ms. Odessa and Edward Hoffman, President of the Tarpon Springs Historical Society and Museum; June Hurley Young; and a special thanks to the volunteers at the Dunedin Historical Museum. An additional special thanks to our little four-year-old assistant, Caroline Grace de Quesada, who can staple a stack of papers in a very efficient and expedient manner.

INTRODUCTION

The Pinellas Peninsula began its history as a county when it was separated from Hillsborough County on January 1, 1912. However, many of the towns and communities that make up Pinellas County predates its separation, when the region was plainly referred to as West Hillsborough, where Tampa had been the county seat. An election within the Pinellas Peninsula decided Clearwater to be the county seat.

The county began to grow and, despite the Depression and two world wars, it prospered as well. Today the beaches of Pinellas County are some of the best in the world, with tourists coming in from every corner of the planet. But the county offers more than just sun and fun. There are cultural attractions as well—from art galleries to historical museums and from baseball to hockey. Pinellas County has become a popular place for all ages, especially for those who decided to stay and call it home.

Many of the old photographs and postcards are the only reminders of places, people, and events that helped shaped the Pinellas Peninsula into what it is today. This historical collection of photographs merely show long-past glimpses of the communities that made up Pinellas County.

The Images of America series is a worthy attempt to bring community heritage together for all to share. There will be numerous projects covering the Tampa Bay area with this series in the future. For Pinellas County, some of the communities will each be dealt with more specifically in future editions, as well as Hillsborough and Manatee Counties. We hope that as you peruse these pages you will become interested in this county's fascinating heritage. For those raised in Pinellas we hope it is a stirring of fond memories.

Alejandro M. de Quesada
Vincent G. Luisi

One

SAFETY HARBOR

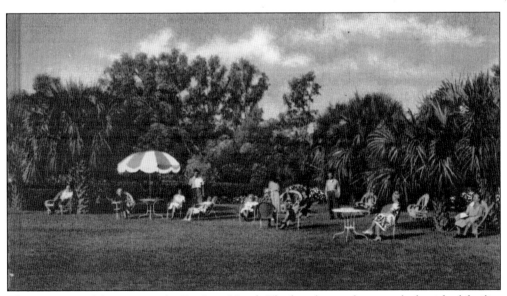

This is a view of the patio at the De Soto Hotel. The hotel was a luxuriously furnished facility which included steam heat, electric elevators, a solarium, and mineral baths. (Courtesy Safety Harbor Museum of Regional History.)

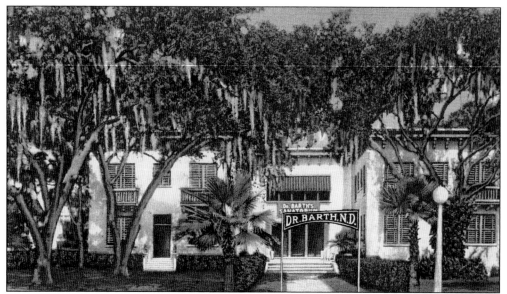

In the summer of 1928 a second bathhouse was opened in Safety Harbor and operated by Dr. Con F. Barth. Barth's bath used the mineral waters from the Pipkin Mineral Wells, which were located across the street. (Courtesy Safety Harbor Museum of Regional History.)

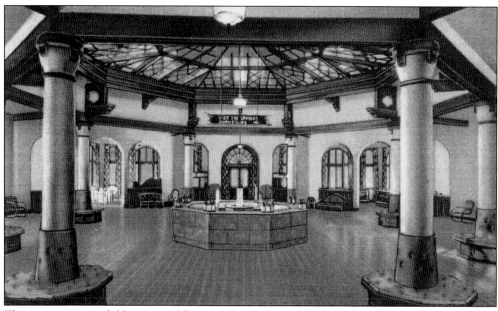

This is an interior lobby view of Espiritu Santo Springs, taken during the 1930s. Here four mineral springs, each having a specific value for different ailments, were housed under one roof. It has been remodeled and is now used as the dining room area for the Safety Harbor Spa. (Courtesy Safety Harbor Museum of Regional History.)

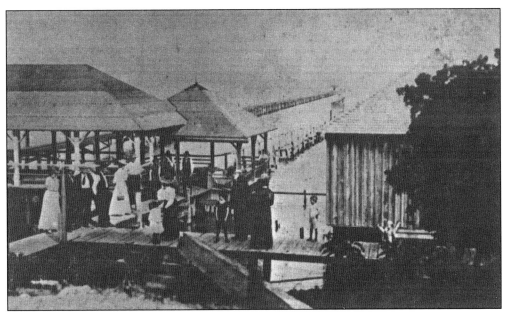

Safety Harbor, formally called Green Springs, was settled in 1853 by John D. Young and William Mobley. The resort was first developed by James Tocher, who built a bathing pavilion, bottling house, and shelter over the springs. A deck was also built that attracted excursion boats to the springs from across the bay. (Courtesy Safety Harbor Museum of Regional History.)

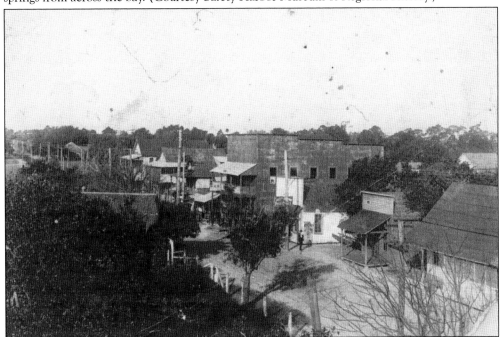

George B. Thomas built the first store in Green Springs, which would become Safety Harbor. John Whiteledge built an open-air dance hall and the Green Springs Inn. Other buildings in the downtown area included a grocery, feed store, barbershop, drugstore, and real estate office. This photograph is of Main Street looking west. (Courtesy Safety Harbor Museum of Regional History.)

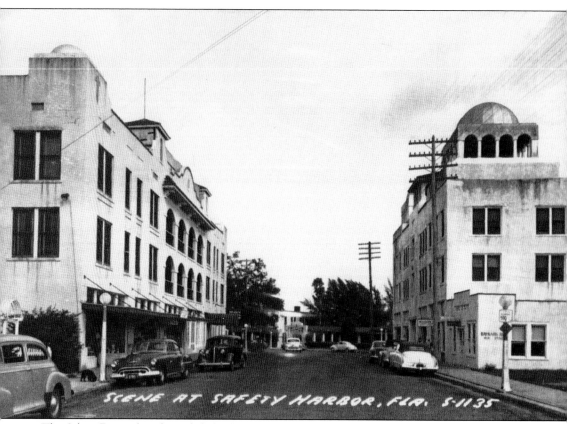

The Silver Dome (on the right), built in 1925, was located across the street from the St. James Hotel, on Main Street. The Spanish-style building was owned by Louis Zinsser and had apartments on the upper floors and stores on the ground level. (Courtesy Safety Harbor Museum of Regional History.)

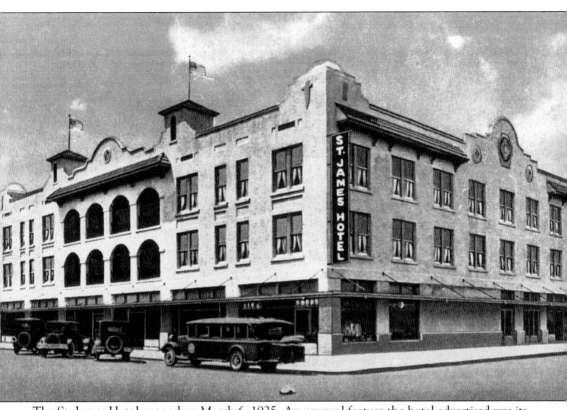

The St. James Hotel opened on March 6, 1925. An unusual feature the hotel advertised was its fire sprinkler system. Today it still stands on the corner of Main Street and Phillippe Parkway, and is known as the Harbor House. The first floor is used for specialty shops. (Courtesy Safety Harbor Museum of Regional History.)

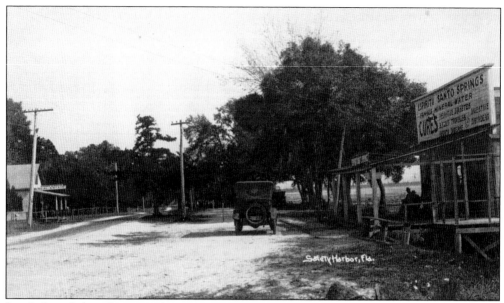

It is believed that the mineral waters in Safety Harbor were named "Espiritu Santo Springs" (Springs of the Holy Spirit) by Conquistador Hernando De Soto when he arrived in the area on May 18th, 1539. As the automobile became available, visitors would drive to Safety Harbor to purchase bottled mineral water and take advantage of the springs "curing effect." (Courtesy Safety Harbor Museum of Regional History.)

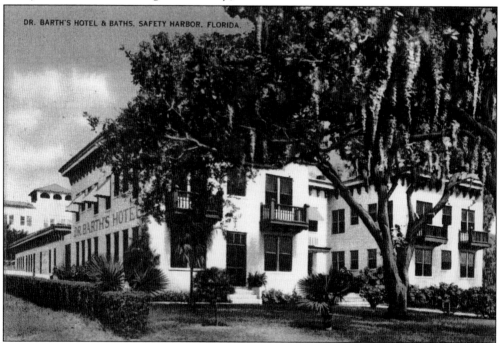

Dr. Barth's Bath and Hotel used one of the five distinct springs in Safety Harbor that was on the Pipkin property. This fifth spring has never been analyzed. The water was pure and had no taste and originated deep underground. Dr. Barth's Bath and Hotel attracted many visitors during the late 1920s and early 1930s. (Courtesy Safety Harbor Museum of Regional History.)

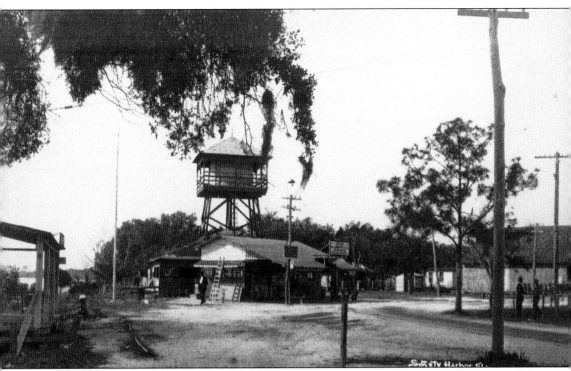

The Water Tower Pavilion, looking down Main Street toward the bay front, was one of the popular landmarks of the city in its early years. The building below the tower is where tourist and residents could take empty jugs and fill them with spring water. (Courtesy Safety Harbor Museum of Regional History.)

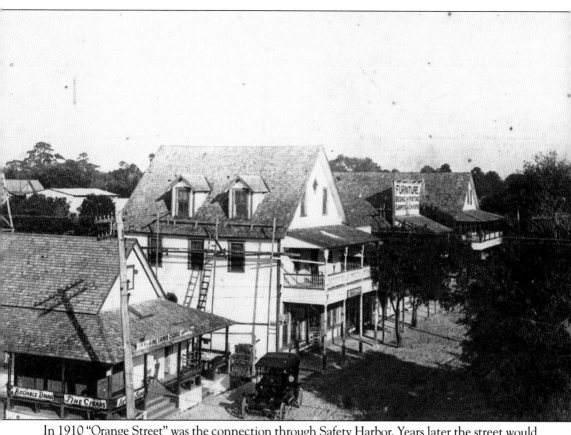

In 1910 "Orange Street" was the connection through Safety Harbor. Years later the street would be renamed Main Street. In the early 1900s the town included a furniture and cigar store. The cigar store was a major store for the time, since it was Safety Harbor's original resident Count Odet Phillippe who was the first cigar maker in the Tampa Bay area and who introduced local cigars to the soldiers at Fort Brooke in what is present-day Tampa. (Courtesy Safety Harbor Museum of Regional History.)

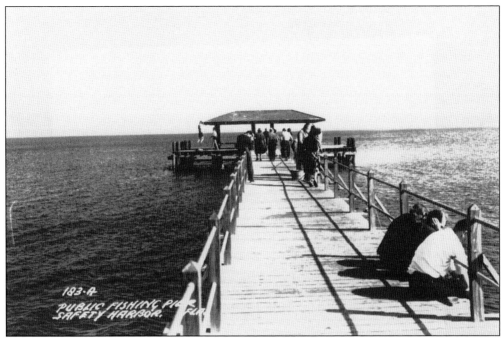

The public fishing pier was used by many tourists and residents for leisure walks and for fishing. At the end of the pier was a dance hall, which was a popular gathering spot. In 1921 the dance hall was destroyed by a hurricane. (Courtesy Safety Harbor Museum of Regional History.)

This photograph was used as a publicity shot to advertise not only the benefits of the healing springs but also to show that couples and families could come to enjoy a vacation at the spas of Safety Harbor. By the 1970s, the spas took on the role of resorts rather than sanitariums. (Courtesy Safety Harbor Museum of Regional History.)

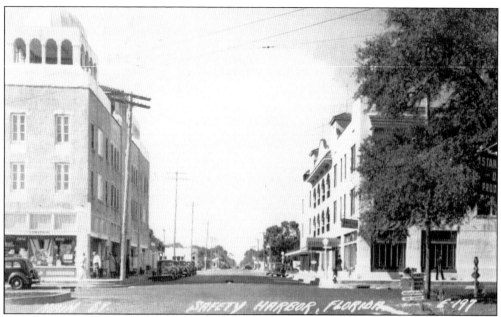

Shown here is a view of Main Street looking west, with the Dome on the left and the St. James Hotel on the right side of the street. The entrance to the hotel was on the Main Street side. Parking on Main Street was limited to five minutes in the front of the hotel, with no parking at the corner. The dome was a downtown landmark for 55 years. In 1981, it was demolished after being designated unsafe for use. (Courtesy Safety Harbor Museum of Regional History.)

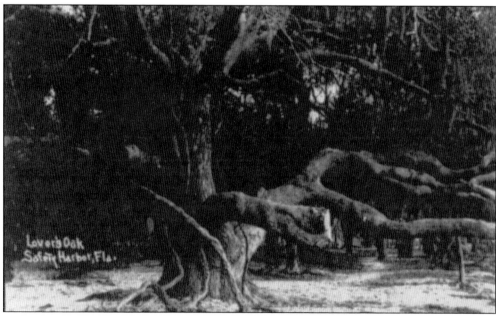

Lover's Oak was a favorite place for lovers to carve their initials and for families to meet for picnics and fish fries. Before 1900, chicken pileau parties were held at Lover's Oak. Chicken and seasoning were put in a large iron wash pot and boiled with rice. After eating, entertainment was centered around the campfire, which lasted until midnight. (Courtesy Patricia Pochureck.)

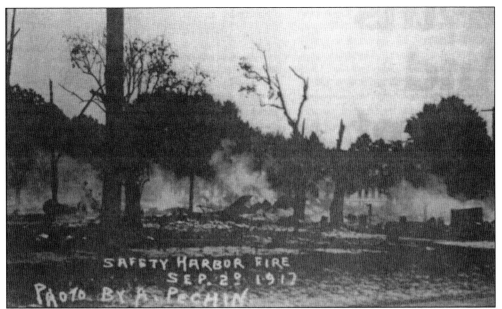

In 1917, the city of Safety Harbor was incorporated. Less than three months later, on September 2, many of its buildings were destroyed by a fire that began in the Safety Harbor Inn. The Tampa Fire Department responded to help but because there was no connecting bridge fire trucks had to go around the bay to get there. By the time the firemen arrived an entire block east of the hotel on Main Street was destroyed. (Courtesy Patricia Pochureck.)

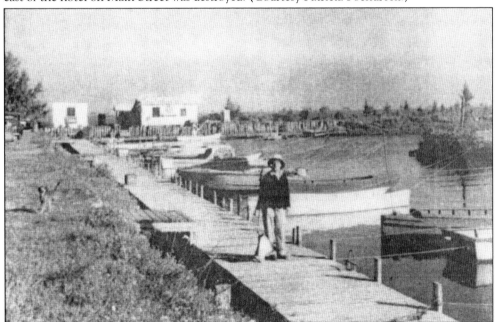

Around the turn of the century developers built a seawall along the bay to develop waterfront properties. The project was not successful, but the landfill site created the city marina, and the area of the Safety Harbor Spa. During the 1950s the harbormaster at the city marina was Mr. A. Jameson, shown in this photograph. Fishing and recreational launches were the typical types of vessels found in the dock area. (Courtesy Patricia Pochureck.)

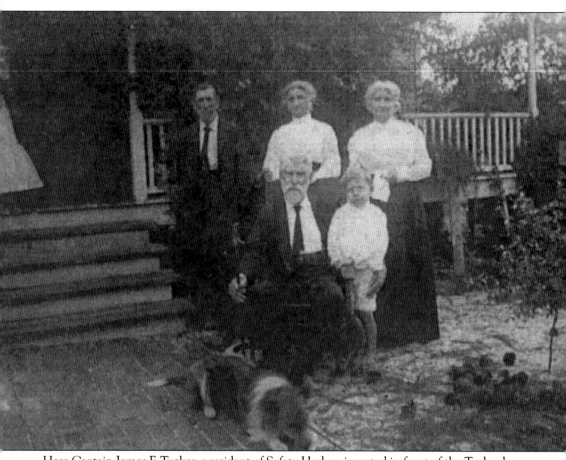

Here Captain James F. Tucker, a resident of Safety Harbor, is seated in front of the Tucker home with friends. Tucker, a Confederate veteran, was well known throughout the community. Mrs. Virginia Tucker later built the St. James Hotel, which she named in memory of the captain. (Courtesy Patricia Pochureck.)

Two

TARPON SPRINGS

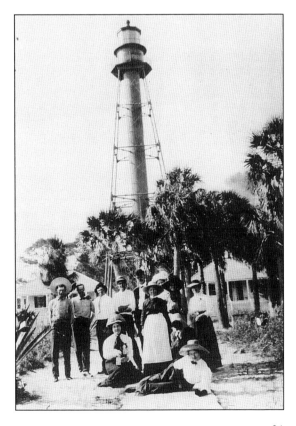

In 1887, a lighthouse was built on Anclote Key by an executive order of President Grover Cleveland at a cost of $35,000. The revolving turret, 101 feet above ground, was turned by weights that had to be wound everyday. This photograph shows visitors at the lighthouse in the early 1900s. Presently, there is a project underway to restore the lighthouse to its original splendor. (Courtesy Tarpon Springs Historical Society and Museum.)

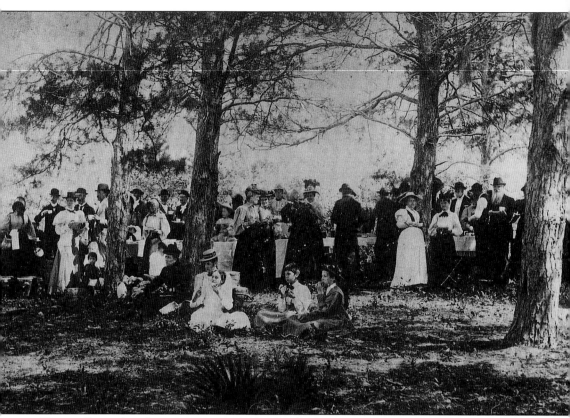

Tarpon Springs's only connection with the Civil War is an event that took place in the late summer of 1864. Deserters from Fort Brooke in Tampa made their way to the mouth of the Anclote River hoping to be picked up by a federal gunboat. A bonfire was built to attract the gunboat but Confederate Captain Samuel Hope, who was a landowner on the Anclote, captured them and hung them on the spot. It became a favorite picnic locale, since it was one of the highest points of land in the area. This was the Ladies Bayou Boat Club in the 1890s. (Courtesy Tarpon Springs Historical Society and Museum.)

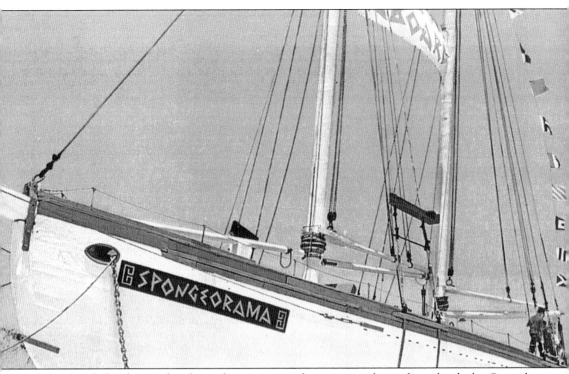

Some Greek families made a living by promoting the sponge industry from the docks. Several diving boats were converted into exhibition vessels which were on display for tourists. Displays such as the Spongeorama showed the history of sponge diving. (Courtesy Tarpon Springs Historical Society and Museum.)

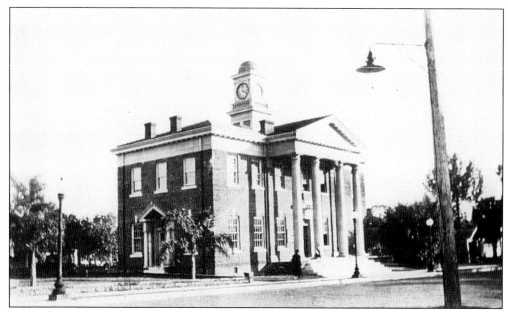

The early 1900s were productive years for downtown Tarpon Springs. The new brick schoolhouse was built in 1912, and the brick city hall was built in 1914. Both of these buildings were sources of civic pride. This photograph shows city hall in 1922. The building today is used for the Cultural Affairs office. (Courtesy Tarpon Springs Historical Society and Museum.)

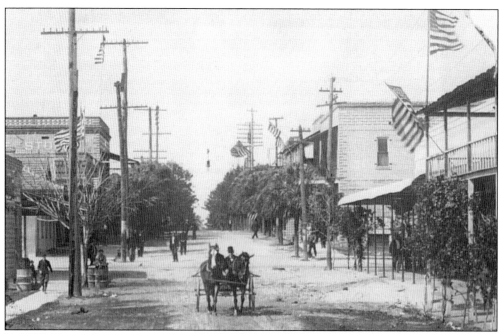

In 1887, Tarpon Springs was incorporated with a population of 52 residents. Some of the stores on Tarpon Avenue included a millinery shop, post office, and oyster house. At that time all the sidewalks were made of cut wood boards laid crosswise and the streets were simple dirt roads that became rivers when it rained. In this scene, the buildings are decorated for a patriotic celebration. (Courtesy Tarpon Springs Historical Society and Museum.)

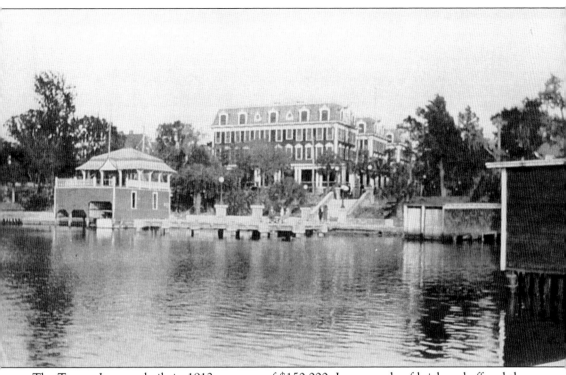

The Tarpon Inn was built in 1912 at a cost of $150,000. It was made of brick and offered the best in comfort. The bedrooms included steam heat and telephones for its guests. The dining and food were considered to be of excellent quality. There was a large boathouse with a second-floor pavilion for dancing and cards. In 1927, the inn burned down. The Scottish Inn is now located on that site. (Courtesy Tarpon Springs Historical Society and Museum.)

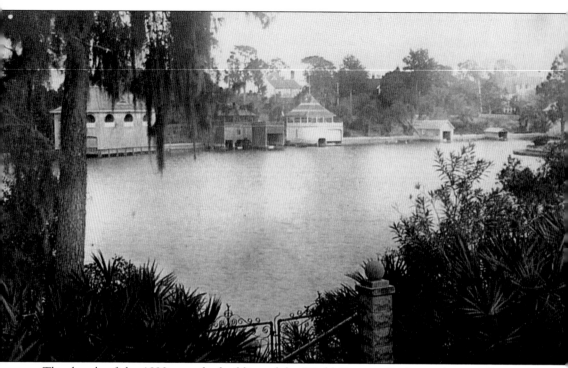

The decade of the 1890s saw the building of the "Gold Crescent," when a dozen millionaires and other wealthy northerners built a half-circle of Victorian homes and boathouses around the head of Spring Bayou. During the early 1900s a fountain was built that would shoot out a 70-foot jet of water that was accompanied by different colored lights. It was around this time that someone coined the phrase "Venice of the South," which has been used to refer to Tarpon Springs and its 35 miles of winding waterfront. (Courtesy Tarpon Springs Historical Society and Museum.)

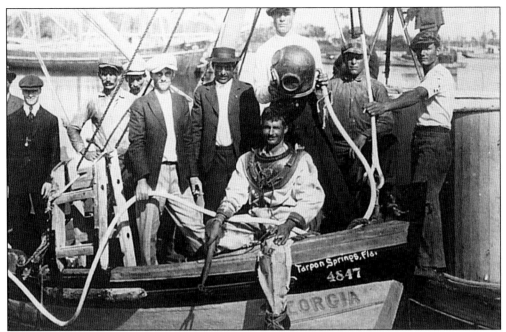

Tarpon Springs was the location for several major movie productions based on the sponge industry. The first was *The Diver*, made in 1932. Other movies included *Sixteen Fathoms Deep* and *Twenty Fathoms Deep*. The last two movies were based on stories by Eustace Adam. This photograph was used for publicity purposes for the original movie *Sixteen Fathoms Deep*, in 1934. (Courtesy Tarpon Springs Historical Society and Museum.)

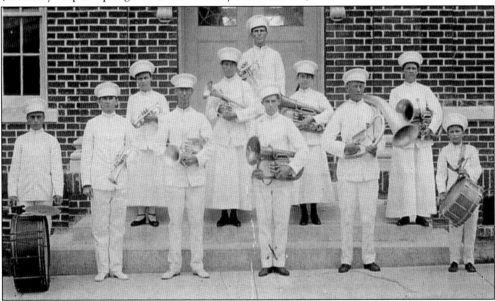

During World War I, patriotism ran high in Tarpon Springs. On Washington's birthday, 1918, there was a pageant at the Tarpon Inn for which Governor Sidney J. Catts was the speaker. The Red Cross organized the entire event, which included card parties, fund-raising events, and parades. This photograph shows the Citizen's Band, which led the patriotic costume parade. (Courtesy Tarpon Springs Historical Society and Museum.)

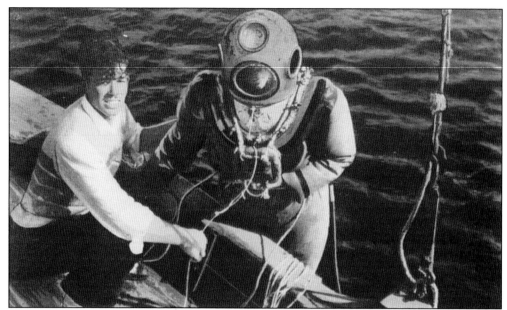

There were two methods used to retrieve sponges from the ocean bottom. The first method was by using a long pole with a hook on it to pull the sponge up. In 1885, the rubberized diving suit with a pumped-in air supply was developed, and used as a more efficient way to collect sponges. Diving was dangerous and many men were killed, but the Greek spongers preferred this method for economical reasons. In this photograph a diver returns to the ship after a day of diving. (Courtesy Tarpon Springs Historical Society and Museum.)

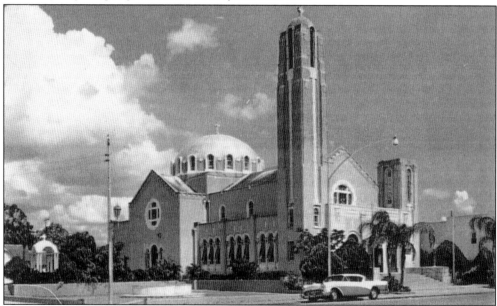

Many Greek immigrants of Tarpon Springs are members of the Greek Orthodox Church. The first church building erected by the Greeks was a simple white-framed building, which was used from 1908 to 1943. It was replaced by the brick Church of St. Nicholas, patron saint of sailors, children, and the poor. Inside the church are mural paintings of saints and apostles done by artist George Saclarides. (Courtesy Tarpon Springs Historical Society and Museum.)

Cafes and restaurants started to develop along the sponge dock during the 1920s. The most famous restaurant was started in 1925 by an ex-army cook, Louis Pappas, who served under the command of General "Black Jack" Pershing in France during the First World War. Along with Louis was his wife, Flora—also known as "Mamma Pappas." This statue commemorates Greek sponge divers and is located outside the front of Pappas's restaurant. The family continues to run establishments along the waterfront. (Courtesy Tarpon Springs Historical Society and Museum.)

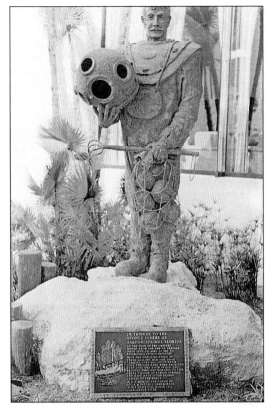

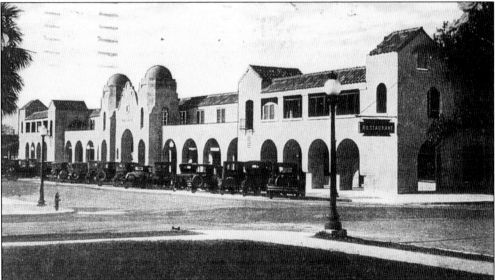

During the 1920s, Florida experienced a real estate boom, and Tarpon Springs was no exception. In 1925, $6,000,00 was invested in the downtown area of Tarpon Springs. Business property was selling for a $1,000 per front foot. The showplace of the city was the pink stucco Spanish-style Shaw Arcade Hotel building, erected at a cost of $100,000. It was managed by A. Ferris Hollis. Today this building still exists on the west side of Pinellas Avenue, with specialty shops on the ground floor. (Courtesy Tarpon Springs Historical Society and Museum.)

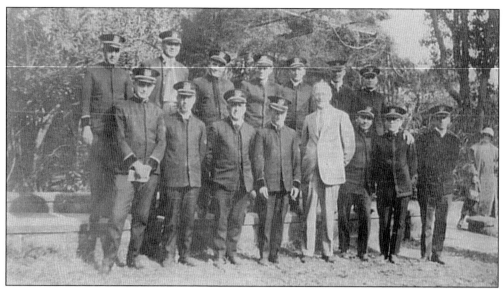

During the 1920s many types of social activities occurred around the park and Spring Bayou. In Spring Bayou, near the water fountain, two 38-foot gondolas were used for rides. The gondolas were acquired from the Exposition in Philadelphia. In the winter season there were daily band concerts in the park. For two seasons, Mr. Bohumir Kryl of Chicago and his 30-piece band entertained the Tarpon Springs residents. This photograph shows Mr. Kryl and some of his band members during the 1924 winter season. (Courtesy Tarpon Springs Historical Society and Museum.)

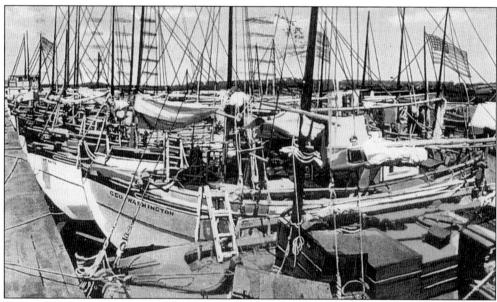

The sponge docks became a bustling base of activity in the early 1900s. The Sponge Exchange became the main center of the sponge industry in Tarpon Springs and the only one of its type in the United States. This provided a good docking area for the spongers, as well as a place to bring their sponges to sell. The Sponge Exchange, founded in 1907, is now on the National Parks Service Register of Historic Sites and has been designated with a bronze historical marker by the State of Florida. (Courtesy Tarpon Springs Historical Society and Museum.)

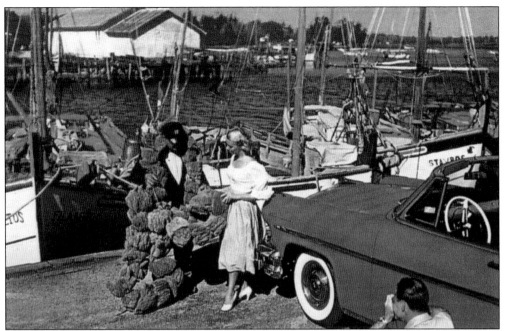

By the late 1940s the sponge industry had declined due to various reasons including the spread of red tide, which lead to the destruction of many sponge beds. The spongers still used the docks but were now sharing it with various restaurants and curiosity gift shops. This photograph shows a merchant displaying his sponge catch to a visiting tourist. (Courtesy Tarpon Springs Historical Society and Museum.)

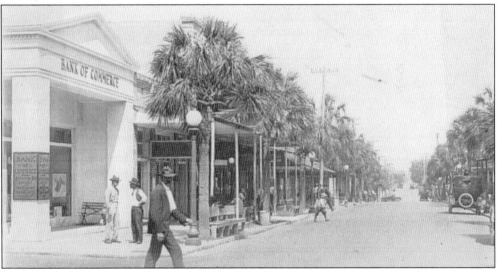

By the late 1920s Tarpon Avenue had been modernized with cement sidewalks and streets, telephone poles, and electric lights. However, things started to change by 1930 due to the stock market crash and the Great Depression. Several of the merchants on Tarpon Avenue started to have financial difficulties. The Bank of Commerce, as seen on the left side of the photograph, went into receivership in 1933 despite assistance from some of its backers. Later that year, the First National Bank in Tarpon Springs was chartered, with federal backing. (Courtesy Tarpon Springs Historical Society and Museum.)

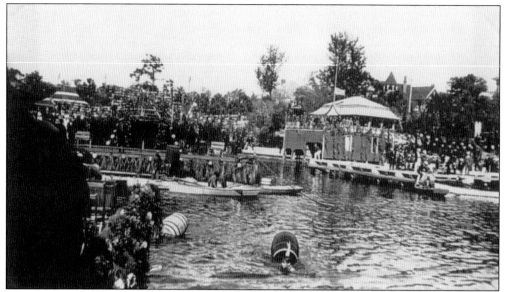

The annual water sports carnival had various activities. In the afternoon tub races were held in the water, and in the early evening there was the water parade of floats that passed through Spring Bayou. Later in the evening, entertainment was furnished by the Tampa Community Players on a floating stage centered in the Bayou. Plays performed in the 1920s included the *Pinafore*, the *Mikado*, and *Midsummer Night's Dream*. This photograph shows the tub races of 1924. (Courtesy Tarpon Springs Historical Society and Museum.)

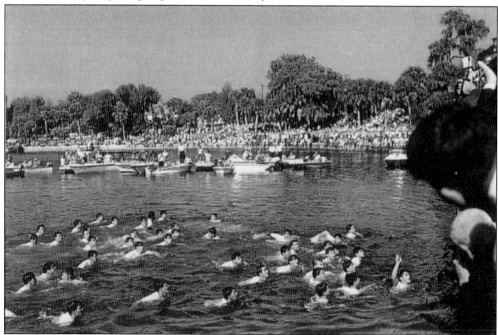

The shores of the bayou are lined with spectators for the "crossdiving" ceremony. After the ceremony the crowd drifts to the Sponge Exchange for an afternoon of Greek food and dancing. The celebration ends in the evening with the formal Epiphany Ball. (Courtesy Tarpon Springs Historical Society and Museum.)

The young boy who retrieves the gold cross brings it back to land. The boy hands the cross to the archbishop and then, kneeling down, receives a blessing, which according to tradition and legend assures that boy of good fortune and luck for the coming year. (Courtesy Tarpon Springs Historical Society and Museum.)

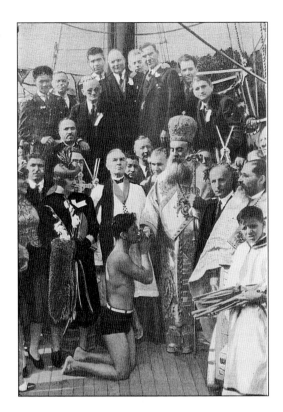

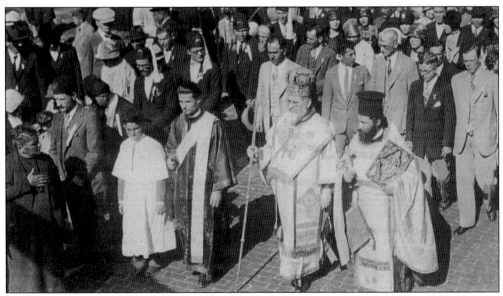

The officiating clergyman is always the archbishop or a distinguished bishop. He is assisted by the priest of St. Nicholas in Tarpon Springs, who for more than 30 years was Father Theophillos Karaphillis. The clergy and congregation form a procession to Spring Bayou, followed by schoolchildren and many others. The church officials wear robes of gold and crimson. A young woman dressed in white carries a white dove (which symbolizes the Holy Spirit) and follows the archbishop to the Bayou. (Courtesy Tarpon Springs Historical Society and Museum.)

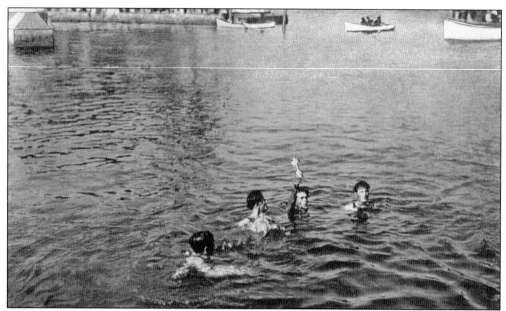

After the invocation by the archbishop, the white dove is released to fly over Spring Bayou. Then the archbishop throws a gold cross into the water, and at that time young boys of high school age leap from small boats formed in a semi-circle and dive underwater to find the cross. (Courtesy Tarpon Springs Historical Society and Museum.)

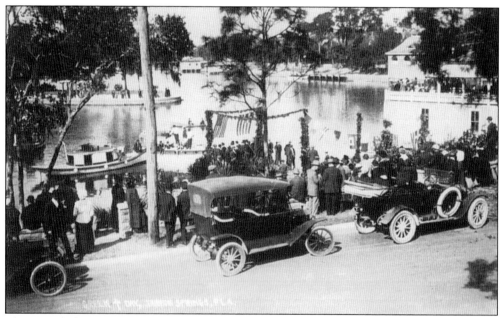

The special observance for which Tarpon Springs is known for is the Greek Epiphany ritual. It is held each year on January 6, and commemorates the baptism of Christ in the River Jordan. The Tarpon Springs Epiphany is the largest Epiphany held in the United States. Spring Bayou is decorated with flags, flowers, and a grandstand for the ceremony. This photograph shows the 1920s festival preparing for the diving of the cross in the bayou. (Courtesy Tarpon Springs Historical Society and Museum.)

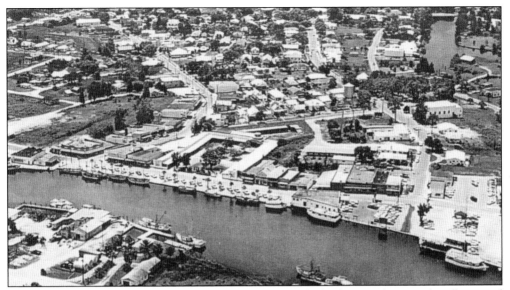

In the 1920s the city built a new seawall for the sponge dock, along with new sidewalks, paved streets, benches, and parking spaces. To honor the Greek community the city changed the name of Anclote Boulevard to Dodecanese. Mrs. Irene Gianeskis opened the town's first curio store in her home, offering corals and other items for sale to tourists. Her store was the first of many shops that would line the docks and nearby areas offering souvenirs. This view of the sponge dock was taken in the early 1960s. (Courtesy Tarpon Springs Historical Society and Museum.)

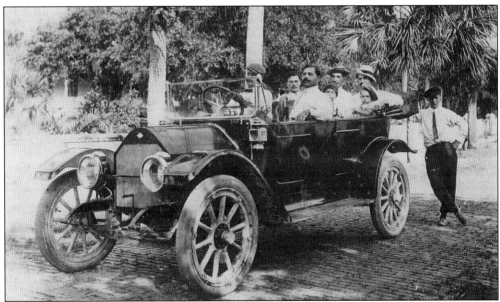

By the 1920s automobiles had become obtainable for many families. With the improvement of roads throughout the county, families would go "automobiling" on the weekends. As automobile travel into Tarpon Springs increased, the community began to be more aware of tourism and the changes it would bring. In this photograph, dated 1924, the Tulumaris family of Tarpon Springs is preparing for a day's outing in an automobile equipped with a driver. (Courtesy Tarpon Springs Historical Society and Museum.)

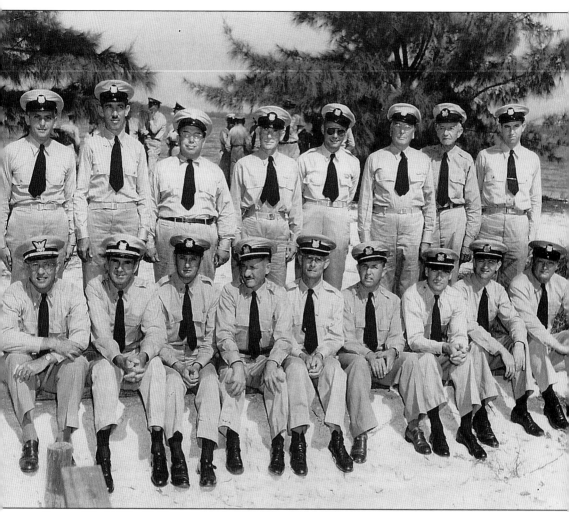

During World War II, Tarpon Springs was actively involved in patrolling the coastal shores for unidentified ships. The Coast Guard controlled all the local ports and were outfitted with eight vessels. Approximately 85 Coast Guardsmen were based in the Seabreeze Building, located on Athens Street. The job of the Coast Guard included registering vessels, granting clearance, and patrolling the beach and river roads. Organizations that worked with the Coast Guard included Tarpon's Coast Guard Auxiliary, as seen in this photograph. Fredrick Howard was in command of the auxiliary's flotilla of boats belonging to local men, who gave one day a week to patrol the harbor. (Courtesy Tarpon Springs Historical Society and Museum.)

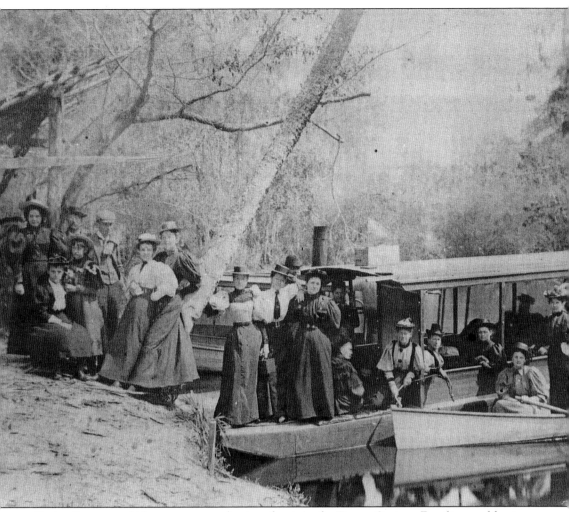

Spring Bayou would become a central point of activity for Tarpon Springs. Families would swim, boat, and enjoy the view and festivals the area offered. By the 1890s many prominent families would build homes around the bayou, including Anson Peaseley Killen Safford, former governor of the territory of Arizona and partner of Disston Enterprises, which helped develop Tarpon Springs. This 1912 photograph shows families strolling around Spring Bayou. (Courtesy Tarpon Springs Historical Society and Museum.)

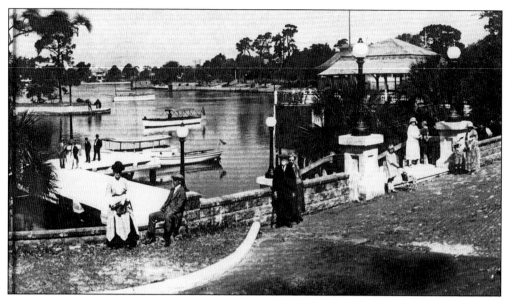

For many years Spring Bayou was a focal point in Tarpon Springs's social activities and life in general. Here is another scene of the area in the years during and following World War I. (Courtesy Tarpon Springs Historical Society and Museum.)

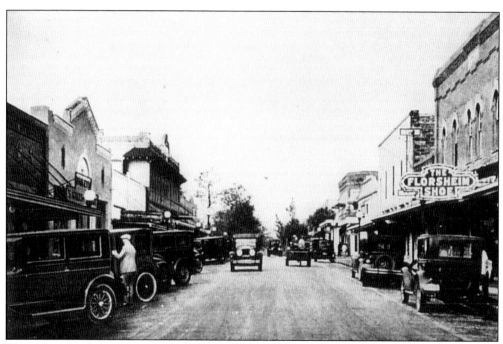

This is Tarpon Avenue as it looked during the late 1920s. The Depression was just around the corner. (Courtesy of the Dunedin Historical Museum.)

Three

DUNEDIN

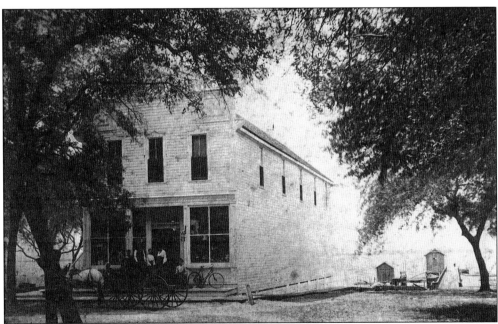

By the 1870s several individuals had tried to open a general store in the settlement, which at times was called Jonesboro, but none had been profitable. By 1878 two Scotsmen had opened the Douglas-Somerville Store, which was to serve a large segment of the population, including the communities of Clearwater and Largo. Douglas and Somerville were also granted a petition to open the community's first post office, which allowed them to officially name the town Dunedin, which is Gaelic for Edinburgh, their Scottish home. This photograph was taken around 1890 and shows the Dunedin waterfront and pier, which was adjacent to the Douglas-Somerville Store. (Courtesy Dunedin Historical Museum.)

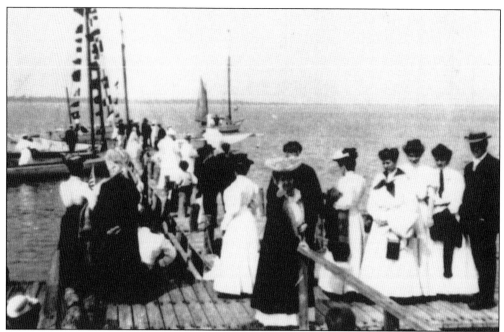

By the late 1880s well-to-do individuals from the Northeast and Midwest found Dunedin to be an ideal place for sailing and picnicing. Many of the wealthy winter residents owned sailboats and were called the Yacht Club Crowd. At one time Dunedin had the largest fleet of pleasure sailing craft on the west coast of Florida. In this photograph the women on the pier are waiting to get into the sailboats to picnic on either Clearwater or Hog Island. (Courtesy Dunedin Historical Museum.)

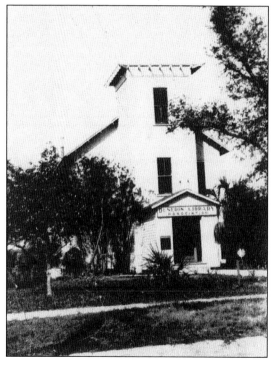

The Dunedin Yacht Club and Skating Rink building was erected in the early 1880s near the center of present Edgewater park. It had a meeting room and two apartments on the first floor; the second floor was used for roller skating, plays, dances, and other holiday entertainment. Eventually, a public library was housed in the building, which became known as Library Hall and served as a community center until it was dismantled in the 1950s. The Dunedin Library is the oldest continuously operating library in the county. (Courtesy Dunedin Historical Museum.)

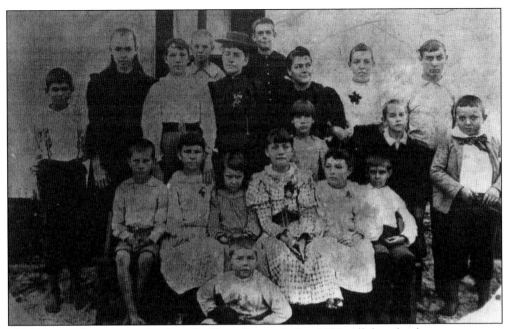

There were at least seven schools in the Dunedin area before 1900. All the schools were one-room buildings with one teacher who taught grades first through fifth. The first school in Dunedin was the Hagler log school. There is no real documentation of this school except for the fact that it was known to have existed as early as 1868 because the Rev. Brown held services in it. The seven schools were located in various areas of the community at different times. This photograph, dated 1894, shows Miss Jenny Criley (the teacher) and children from the Hazelief, Allen, Andrews, McClung, Emerson, Young, and Adams families. (Courtesy Dunedin Historical Museum.)

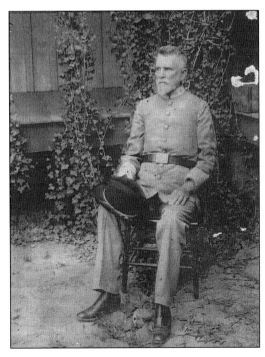

Dunedin did not exist prior to the Civil War, except for one or two homesteaders such as Richard Garrison, who lived near Curlew Creek in 1852. However, Dunedin did have a few Civil War veterans living in the town by the late 1890s. One of the veterans to live in the area was William Conway Zimmerman, a captain in the Confederate army. Captain Zimmerman lived with his wife, Laura Goree, and his son, who was the first in the area to drill wells to replace surface water wells. Captain Zimmerman is shown here wearing his reunion uniform of the United Confederate Veterans. (Courtesy Dunedin Historical Museum.)

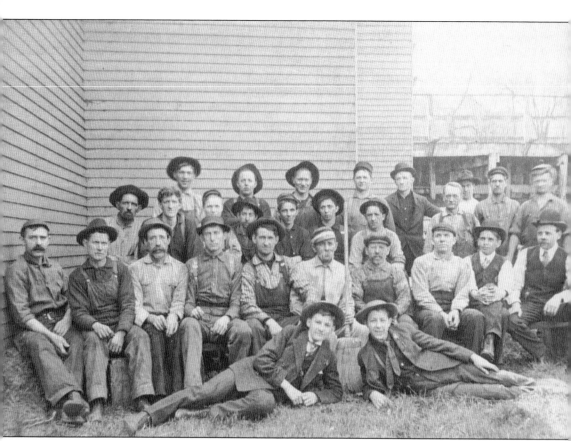

Around 1880 citrus replaced cotton and vegetables as the main commercial crop. Citrus-growing underwent rapid expansion at this time. All was going well for the industry until the winter of 1894–95, when the "Great Freeze" occurred, dropping temperatures into the teens and twenties and killing many of the trees. Many grove owners gave up the groves at low prices and left the area. Those who remained were able to buy up the damaged groves and eventually profited in the future. This photograph is of grove workers and company officials of the Emerson Grove in the 1890s. (Courtesy Dunedin Historical Museum.)

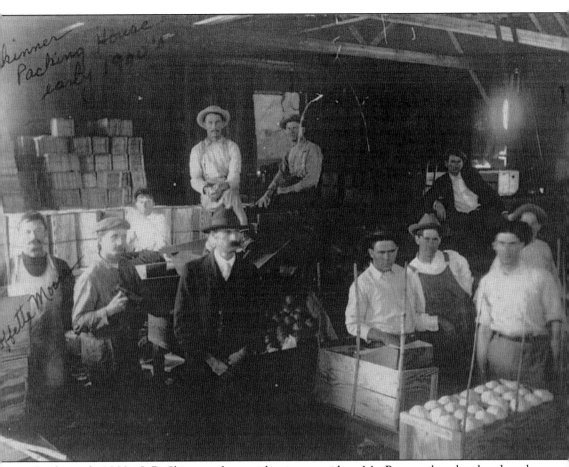

In the early 1900s, L.B. Skinner, along with winter resident Mr. Bouton, bought abandoned groves left from the great freeze of the 1890s. The operation grew and Skinner hired packers and invented machinery to wash, sort, and grade the fruit, which increased his profits and bought out Mr. Bouton's interest. By 1913, Mr. Skinner and his son Bronson improved on the packing machinery and started to sell it to other growers. They incorporated their business and called it the Skinner Machinery Company. It eventually became the largest manufacturer of packing-house equipment. This view of the interior of Skinner's packing house is from the early 1900s. (Courtesy Dunedin Historical Museum.)

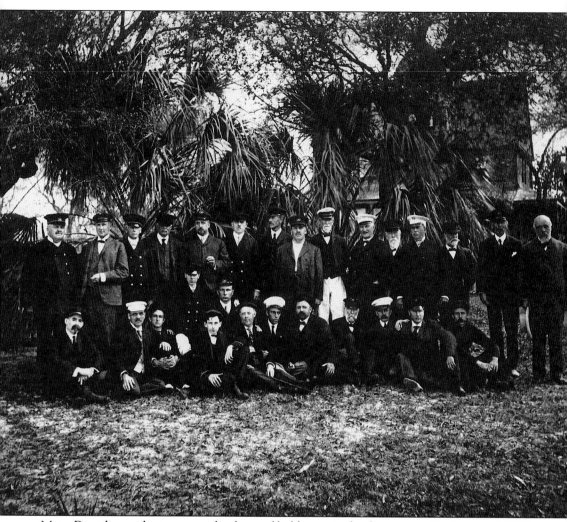

Many Dunedin residents were avid sailors and held organized sailing events. On January 6, 1903, a meeting was held by all of the interested residents of Dunedin to organize a yacht club. On February 9, 1903, a formal constitution was adopted and 16 individuals became the charter members of the Dunedin Yacht Club of Florida. As part of the charter it was accepted that the organization would include competitive races so that the club would not just be a social group. Mr. L.H. Malone donated a silver cup, calling it the Competitive Cup, and names of the winners of the yearly races were to be inscribed on the cup. Here is a photograph of the yacht club members between 1903 and 1904. (Courtesy Dunedin Historical Museum.)

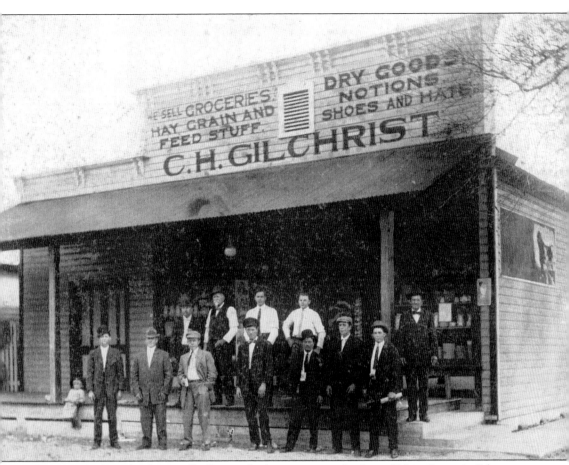

By 1902 the Douglas-Somerville Store, which was now at the foot of Main Street in Edgewater Park, had been sold to Charles H. Gilchrist. Around 1903 there was a fire that destroyed the original building and Mr. Gilchrist moved his store closer to the new railroad that had arrived in town. Here is a photograph taken in 1911 at the Gilchrist Store, which was located on the northeast corner of Main Street and Railroad Avenue. (Courtesy Dunedin Historical Museum.)

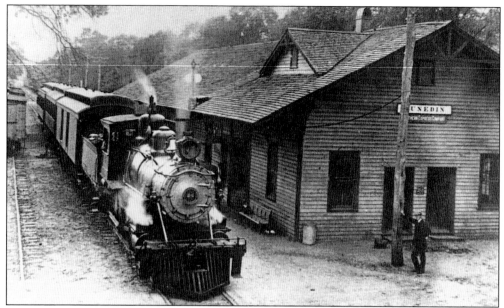

The first railroad arrived in Dunedin in 1888, and was called the Orange Belt Railroad. It was a narrow-gauge track running from St. Petersburg to Tarpon Springs. A boxcar used as the first depot was eventually replaced with a structure of Russian design because the head of the railroad, Mr. P. Dementieff, was originally from Russia. This photograph, taken c. 1912, shows the third railroad station built after the Orange Belt was taken over by the Plant Railroad System. (Courtesy Dunedin Historical Museum.)

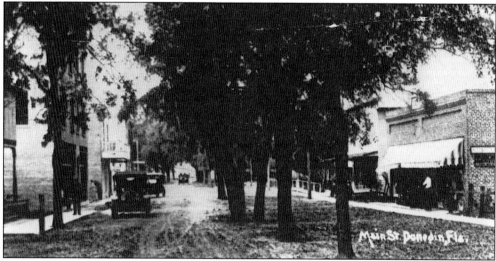

In the early 1900s, Main Street from Douglas Avenue to Edgewater Drive was a shaded road of large oaks. The city of Dunedin was incorporated in 1899 and the town council soon started to make changes. By 1910, the town council decided that Main Street should be improved and the oaks would have to be removed. A strong protest was made to stop this but was voted down. When a crew of men started to cut the trees several ladies of the community came down and sat on the saws. The town marshall dismissed the workmen and the ladies went home. When the ladies returned the next day to protest they found the oaks had been cut down very early that morning, before they arrived. (Courtesy Dunedin Historical Museum.)

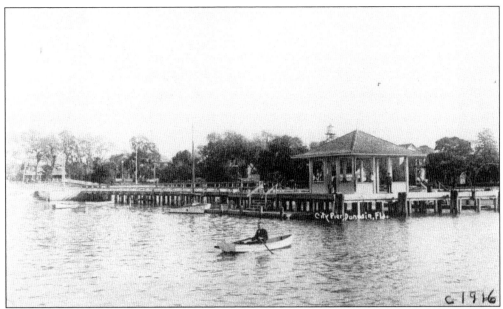

The Dunedin Pier was always an integral part of Dunedin's history. Supplies came in to this pier before the railroad came to town. The pier was also the main stop of travel for shippers who would run supplies from Cedar Key to Key West. By 1916, it had become more of a recreational center for the community for fishing and sailing. In this 1916 photograph, a resident rows past the newly extended pier with its new pavilion. (Courtesy Dunedin Historical Museum.)

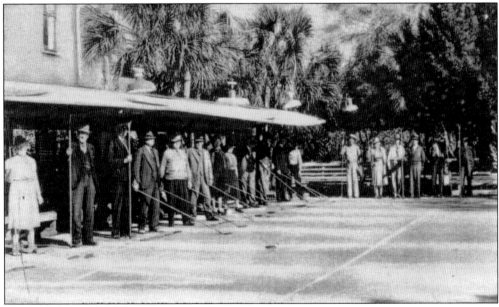

Edgewater Park in Dunedin contained many activities for the community. This was the site of Library Hall and many holiday celebrations. It was also a recreational area for residents to enjoy and included tennis and shuffleboard courts. A large group of Dunedin residents and tourists is shown here playing shuffleboard in the park. A shuffleboard club was organized in 1935 and grew to a membership of over 450 members. The shuffleboard courts were eventually removed to make a playground for children. (Courtesy Dunedin Historical Museum.)

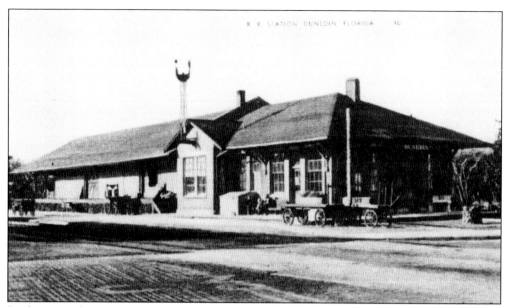

By the 1920s the railroad company had changed holdings again and was now run by the Atlantic Coast Railroad system. In this postcard, dated 1922, the newly completed brick railroad station is displayed after a fire had destroyed the previous wooden station. The railroad would eventually become the holdings of the Seaboard Coastline, and finally CSX. In March of 1987 the last train ran past the Dunedin Station and shortly after that the tracks were taken up to make way for the Pinellas Trail. Today, the railroad station is the home of the Dunedin Historical Museum. (Courtesy Dunedin Historical Museum.)

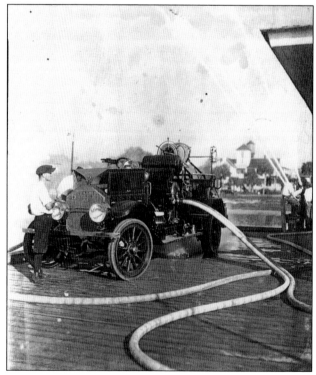

The Dunedin Fire Department was organized in 1913. At that time there were 14 volunteer firemen and a Model T firetruck. In 1922 Henry Houghton was appointed fire chief, a position he held until 1945, and a 1922 American LaFrance firetruck was purchased for $12,500. It arrived in February 1923 at the Dunedin Railroad Station and was immediately tested, as seen in this photograph taken at the Dunedin City Dock. This truck is still in the possession of the Dunedin Fire Department. (Courtesy Dunedin Historical Museum.)

In 1944 the Dunedin Police Department consisted of Chief George Davis and two police officers, one of whom was Eugene Sheets (seen in this photograph), who took over as chief in 1948. The police office was located in a back room at city hall. By 1959, the police department had ten officers, two patrol cars, and one motorcycle. Chief Sheets was highly respected by all residents of Dunedin. He retired in December 1967, after 19 years as chief. (Courtesy Dunedin Historical Museum.)

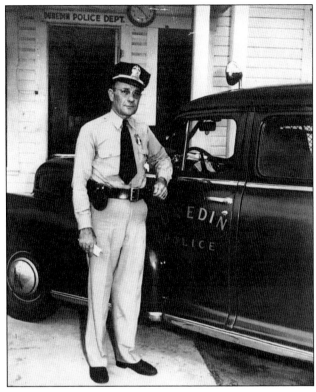

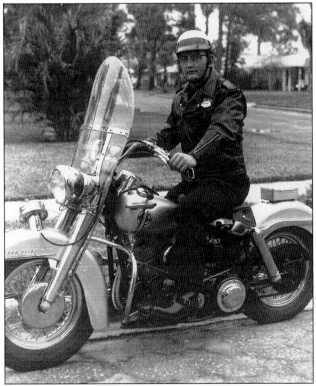

By 1959, the Dunedin Police Force had its first and only motorcycle police officer. The officer assigned to this duty was Bobby Ayers, seen in this photograph. In 1958 the police department took over the entire city hall building at Main and Virginia as their headquarters. The Dunedin Police Department continued to grow until 1994, when the city commission voted to disband the force to save city funding and start utilizing the services of the Pinellas County Sheriff's Department. (Courtesy Dunedin Historical Museum.)

In 1938, Clinton M. Washburn purchased the northern half of Caladesi or Hog Island for $25,000 from a group of Tampa businessmen. He came up with the idea to use the island as a honeymoon getaway for newly married couples. *Life* magazine covered the story in 1940. Fifty rustic cottages were built on "Honeymoon Island," along with several all-purpose recreational and dining buildings. To get to Honeymoon Island, couples took a charter boat. When the United States entered World War II, the island was used by a defense manufacturer for a resort for their employees. This photograph shows a happy honeymoon couple in front of their cottage. (Courtesy Dunedin Historical Museum.)

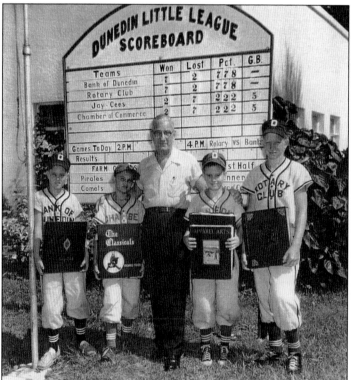

Here Edward H. Eckert (center) is flanked by Little Leaguers from teams sponsored by the Bank of Dunedin, the chamber of commerce, Jaycees, and the Rotary. Little League baseball was started in Dunedin in 1954 by the Dunedin Jaycees. The four teams formed by the organizations above played their games at Fisher Field. A second league, called the American League, was formed in 1960 and played at Grant Field. (Courtesy Dunedin Historical Museum.)

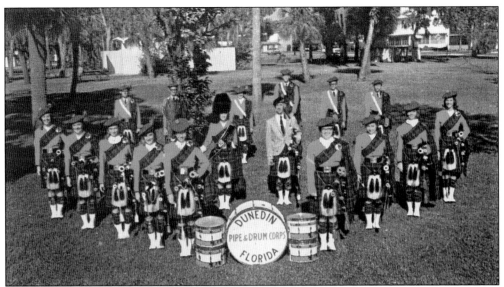

The first sound of pipes in Dunedin was heard in 1957. A Scottish lord, Roy Thomson, donated the first set of pipes at the encouragement of Bob Longstreet, a local reporter with the *St. Petersburg Independent* and a former mayor of Dunedin. Highland Middle School bandmaster Bill Allen liked the idea of a marching band with bagpipes and secured the services of Matt Forsythe, originally from Scotland. The pipes became a tremendous success. (Courtesy Dunedin Historical Museum.)

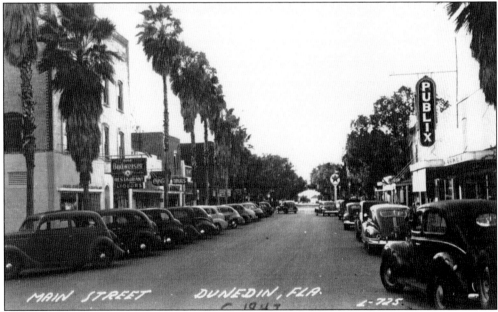

Dunedin's first "super" market was the Publix Market on the north side of Main Street. This market and the name Publix were owned by W.E. "Ed" Humphrey. He eventually would sell the name and rights to Mr. Jenkins of Winter Haven, who owned several other food companies and developed the Publix Markets food chain in Florida. This photograph was taken in 1947, looking west on Main Street toward the Dunedin City Pier. Note how parking was diagonal on the south side and parallel on the north side. (Courtesy Dunedin Historical Museum.)

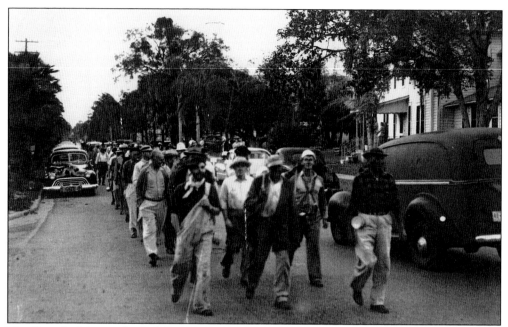

The Dunedin Masonic Lodge No. 192, Free and Accepted Masons is one of the oldest continuous organizations in the city of Dunedin. The concept of having a Masonic lodge in Dunedin dated back to the fall of 1914 and the lodge was fully chartered in early 1916. One of the special functions the Masons held was the annual Hobo parade in downtown Dunedin. The members would dress up like hoboes and parade through town, then have a lunch of Mulligan stew. This photograph shows the Hobo parade going through town in the late 1940s. The present-day Masonic lodge is located on Michigan Boulevard and was built in 1964. (Courtesy Dunedin Historical Museum.)

War comes to Dunedin. During World War II, a Civil Defense air raid observation tower was constructed over Library Hall. At this same time the old Dunedin Hotel was converted into a U.S. Marine barracks. (Courtesy Dunedin Historical Museum.)

Donald Roebling, Dunedin's most colorful character, helped bring wartime prosperity to Dunedin. He designed an amphibious vehicle, initially for rescuing hurricane victims, that was accepted for use by the U.S. Marine Corps as a landing assault vehicle. When war broke out the Marines established a training facility in Dunedin to train drivers in the operation of Roebling's "Amtracs." Roebling is seen here being awarded the Navy's Award of Merit following the end of the Second World War. (Courtesy Special Collections, University of South Florida.)

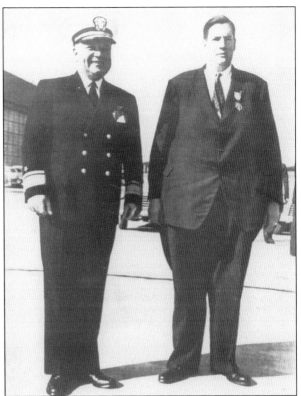

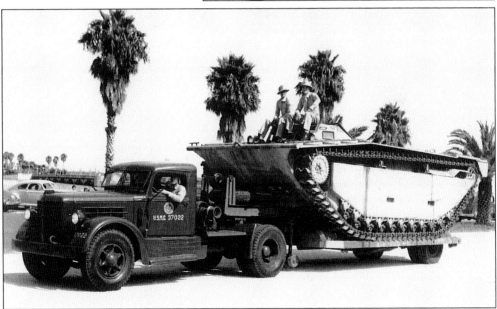

One of a few variations of the Alligator made for the navy by Roebling, is the LVT1 "Amtrac." Many of the vehicles were manufactured by the Food Machinery Corporation (FMC), with plants in Dunedin and Lakeland. This LVT is being transported through the streets of St. Petersburg by Marines. Note the bridge that connected Snell Isle with Coffee Pot Boulevard in the background. (Courtesy St. Petersburg Historical Society.)

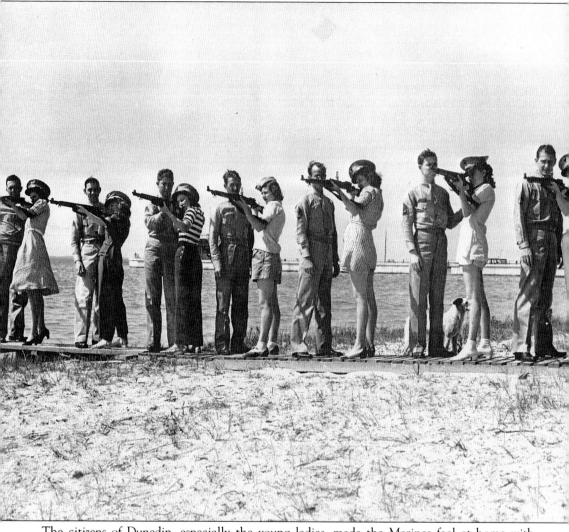

The citizens of Dunedin, especially the young ladies, made the Marines feel at home with numerous parties and dances throughout the war years. In return the Marines showed their appreciation to the citizens of Dunedin, especially the young ladies. Here Marine NCOs are seen giving aiming tips to these ladies on the training grounds of the Marine barracks. (Courtesy Dunedin Historical Society.)

Four

OLDSMAR

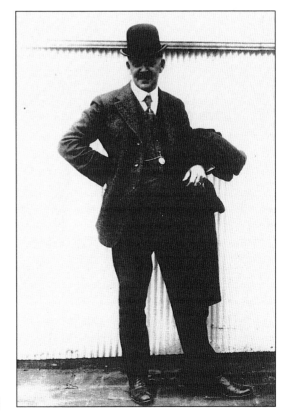

Oldsmar had its beginnings in 1915, when Ransom E. Olds, pioneer automobile manufacturer, traded an apartment house plus cash and bonds for 37,540 acres of land on Old Tampa Bay. Olds envisioned a place for agriculture and industry and designed the community not for the affluent class but for individuals of modest living. (Courtesy Oldsmar Cultural Affairs Department and Oldsmar Public Library.)

REOLDS FARMS COMPANY
The Fastest Growing Town in Florida.
Town Lots and Residences Ready for Occupancy.

Olds organized the R.E. Olds Farm Company to develop the land and the first name chosen for the property was R.E. Olds-On-The-Bay, which was later changed to Oldsmar. A large demonstration farm was put into operation and a number of experienced Florida farmers were added to the staff to assist the new arrivals from the north in becoming established. The timber cut from the farms that were cleared was sawed into lumber at a mill established by Mr. J. Bornstein, and later at another mill owned by the R.E. Olds firm. (Courtesy Oldsmar Cultural Affairs Department and Oldsmar Public Library.)

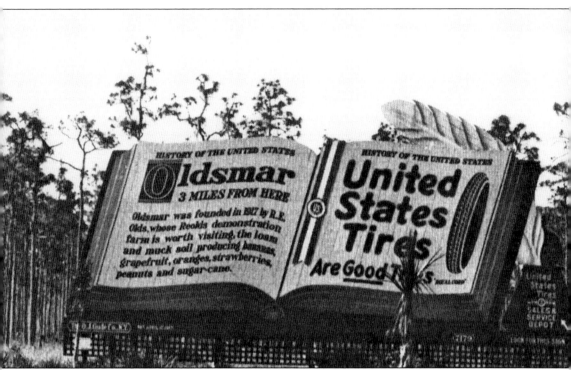

This publicity photo shows Oldsmar's local billboard giving directions on how to get to the community as well as a small history on the development of the town. This sign is one a traveler may have seen as he left Tampa heading toward Oldsmar. United States Tires used the billboard for promotion and placed signs similar to this throughout the area. (Courtesy Oldsmar Cultural Affairs Department and Oldsmar Public Library.)

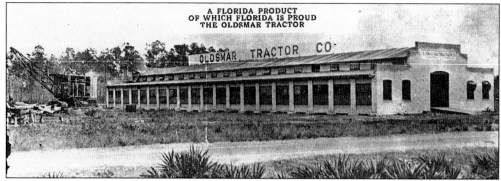

Mr. Olds knew that he needed available jobs to establish the town, so he interested the Kardell Tractor and Truck Company in opening a plant in Oldsmar. One of the reasons Kardell decided to try a plant in the area was because of the lower pay scale that could be used in Florida. More than 1,000 residents of Lansing, Michigan, followed Olds to Oldsmar in search of an ideal community. (Courtesy Oldsmar Cultural Affairs Department and Oldsmar Public Library.)

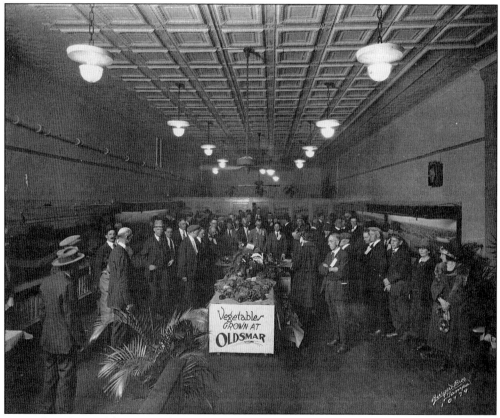

As residents learned farming techniques, various types of fruits and vegetables were grown, such as melons, beans, sugar beets, and corn. The community decided to promote their farming skills by displaying some of their vegetables at the Florida State Fair in Tampa during the early 1920s. This photograph shows some of the state fair judges voting on their choices. (Courtesy Oldsmar Cultural Affairs Department and Oldsmar Public Library.)

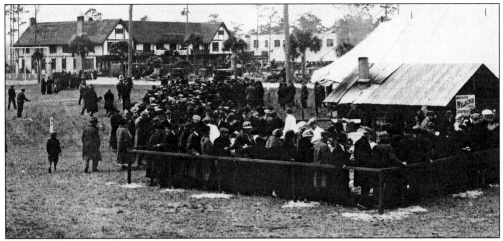

Across the street from the Wayside Inn was a public park which had regular orchestra concerts every Sunday afternoon. To attract large crowds to invest in the community the town would stage free barbecues during the winter. Notice that the event, which was held in winter season, was held in weather cold enough to require heavier jackets. (Courtesy Tampa-Hillsborough County Public Library System.)

Mr. Olds tried various ventures in Oldsmar to attract new residents to the community. He even drilled for oil in Oldsmar, which brought out curiosity seekers but very few new residents. (Courtesy Oldsmar Cultural Affairs Department and Oldsmar Public Library.)

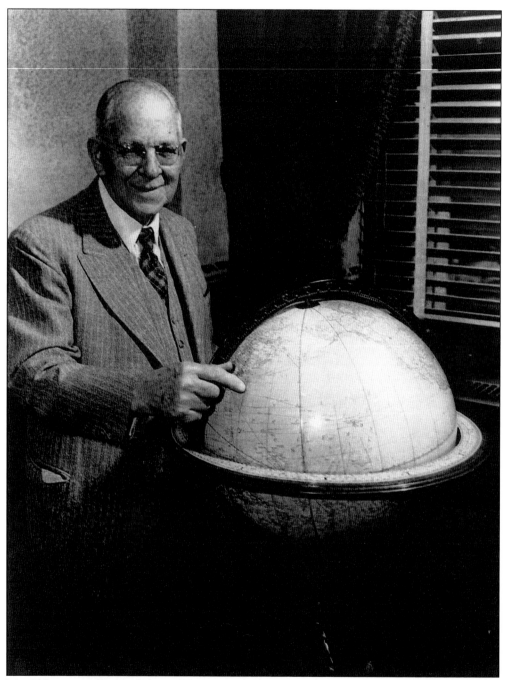

Mr. Olds eventually decided to sell his property shares of Oldsmar in 1923 when he retired. He had spent $4,500,000 and the town had only 200 inhabitants. His plans for a model city never developed, but the Florida land boom was taking off and he sold all his land for the Fort Harrison Hotel in Clearwater and cash. This photograph shows Mr. Olds in his later years, after he had left Oldsmar. (Courtesy Oldsmar Cultural Affairs Department and Oldsmar Public Library.)

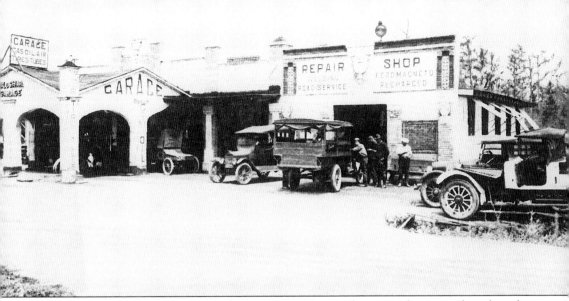

This is the Oldsmar garage as it looked in 1924. The employees at the garage kept busy by recharging Ford magnetos from the tractor factory. Business became increasingly slower when the factory closed, but had a resurgence during the Florida land boom when tourists came through from Tampa on weekend automobile trips. (Courtesy Tampa-Hillsborough County Public Library System.)

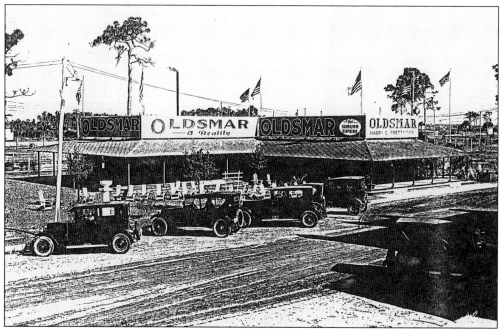

After Olds sold his property to other holders, advertisements such as this were placed around the area to promote the selling of lots in Oldsmar. Mr. Prettyman and associates continued to sell real estate but their efforts to revitalize the town failed. Eventually the lots became overgrown and rundown. (Courtesy Oldsmar Cultural Affairs Department and Oldsmar Public Library.)

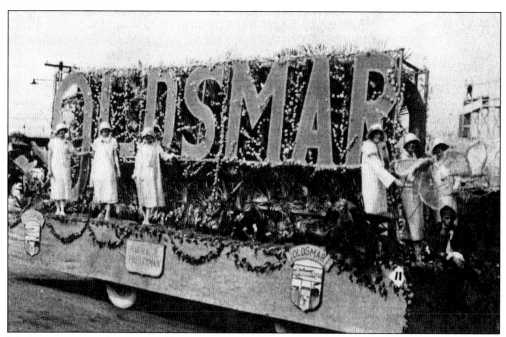

Mr. Prettyman tried various publicity stunts to advertise the community of Oldsmar. Pretty girls and flowers cover this float that was featured in the 1924 Gasparilla Parade in Tampa. (Courtesy Oldsmar Cultural Affairs Department and Oldsmar Public Library.)

Eventually most of the vacant lots came into possession of the B.L.M. Corporation, which was composed of Mr. Bland, Mr. Leeper, and Mr. A.B. McMullen, with Mr. J.A.B. Broadwater becoming the general manager. The new owners changed the name of the town from Oldsmar to Tampashores, and it was incorporated in 1926, with Mr. E.W. Lehman serving as the first mayor. Bathing beauties were used to publicize Oldsmar during the Florida land boom. (Courtesy Tampa-Hillsborough County Public Library System.)

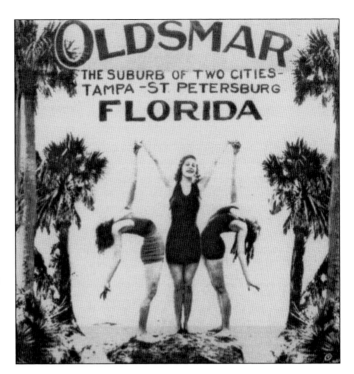

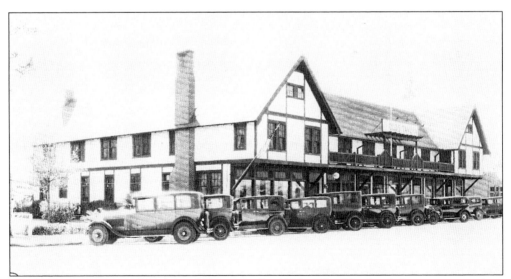

There were at least two hotels in Oldsmar in the 1920s. The Wayfarer's Inn was situated on State Street, and another hotel was being built on Shore Drive. The Wayside Inn was also known as the Olds Tavern, which offered room and board and was a local dining spot. At its highpoint of visitation, the Wayside Inn ran daily buses from Oldsmar to attractions in the area. The Wayside Inn burned in a fire in the 1940s. The other hotel was partially destroyed by a tidal wave and eventually the first floor became a private residence. (Courtesy Oldsmar Cultural Affairs Department and Oldsmar Public Library.)

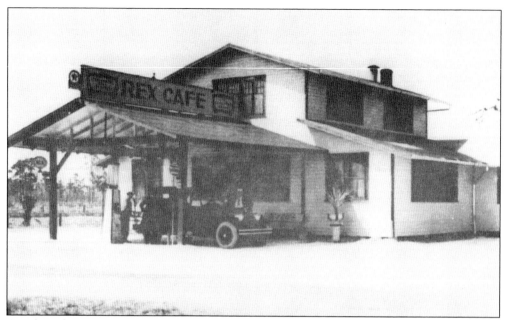

Another place in Oldsmar for food and gas was Rex's Cafe. When the town changed from Oldsmar to Tampashores many changes and improvements were made in the first two years. Streets were paved, sidewalks constructed, new residences were built, and the tractor factory was sold. However, three major events sent Tampashores into decline: the end of the Florida land boom, the 1927 tidal flood in Oldsmar, and the 1929 stock market crash. By 1937, the citizens had changed their town's name from Tampashores back to Oldsmar. (Courtesy Oldsmar Cultural Affairs Department and Oldsmar Public Library.)

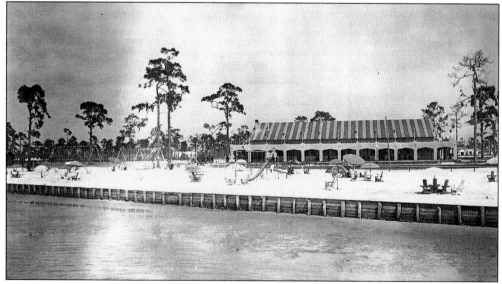

The Casino, located on the waterfront and beach of Oldsmar, was a popular gathering spot during the 1920s. The beach area included recreational activities for local bathers and children. In 1927, a tidal wave hit Oldsmar with water levels of 15 feet high in the center of town. Many people fled for their lives and many homes were destroyed. (Courtesy Oldsmar Cultural Affairs Department and Oldsmar Public Library.)

Oldsmar's beautiful beach area was a wonderful place for social activity and evening car drives. Paths that ran parallel to the beachfront were used for picnic stops and evening social gatherings. In this photograph couples are taking advantage of the view of Oldsmar Bay. (Courtesy Oldsmar Cultural Affairs Department and Oldsmar Public Library.)

The city hall, pictured here in the 1970s, was the home of the Women's Club, the board of trade, Oldsmar Growers Association, the Boy Scouts, the Odd Fellow's and the Masonic lodges, and the Oldsmar Bank during R.E. Old's time. In the last few years Oldsmar has gone through a downtown revitalization and has built a new city hall and administration building across the street from this building on State Street. Today this building houses the Oldsmar Public Library. (Courtesy Oldsmar Cultural Affairs Department and Oldsmar Public Library.)

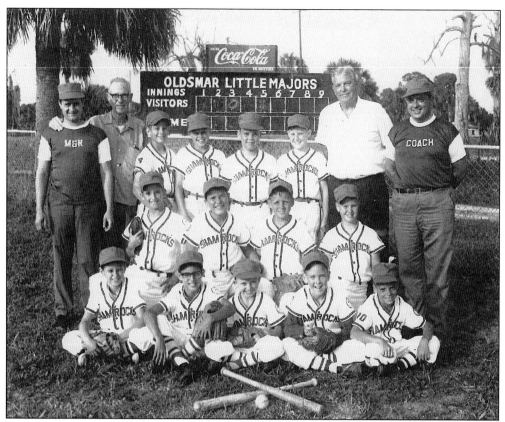

Today the waterfront of Oldsmar features R.E. Olds Park, in memory of Mr. Olds and his vision of a thriving community. The park is used for a variety of uses including a picnic area, fishing pier, nature walk, and baseball field for Little League teams like the Shamrocks, a local Oldsmar team of the 1960s. (Courtesy Oldsmar Cultural Affairs Department and Oldsmar Public Library.)

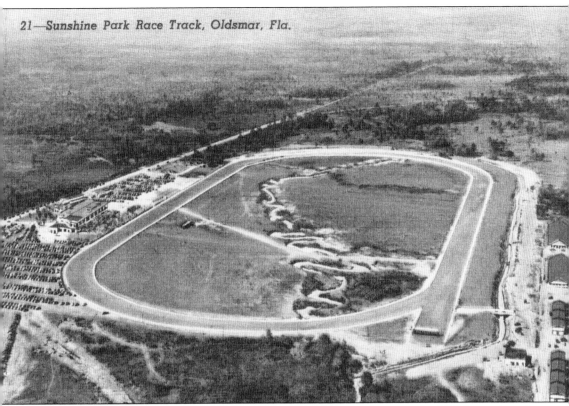

In later years a horse track was constructed north of Oldsmar, between the Hillsborough and Pinellas County lines. Endeavors such as these helped the small community to prosper. (Courtesy A.M. de Quesada Collection.)

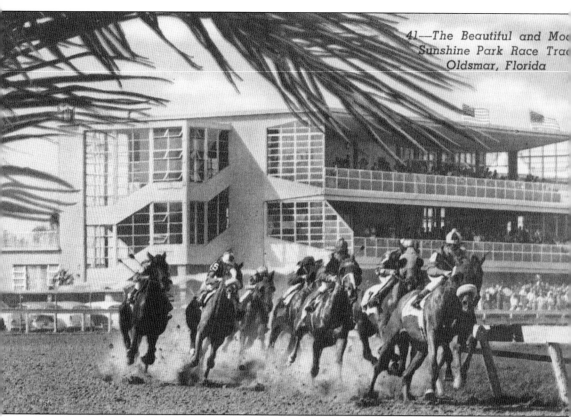

Eventually the Sunshine Park Race Track would be known as Tampa Bay Downs. The facility was shut down during World War II and was used as a storage facility by the army for nearby Drew Army Air Field. (Courtesy A.M. de Quesada Collection.)

Five

PALM HARBOR

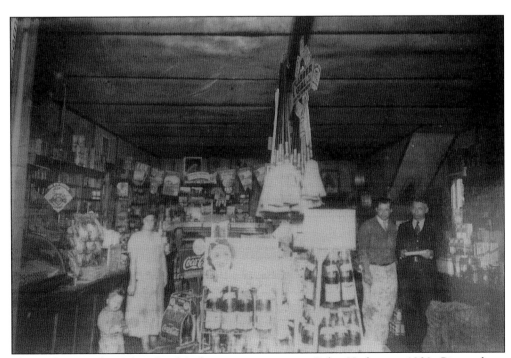

Shown here is the Adair family's first grocery store in Palm Harbor, c. 1939. Pictured are members of the Adair family: Dewey, Connie, their son Ronnie, and a salesman. (Courtesy Palm Harbor Historical Society.)

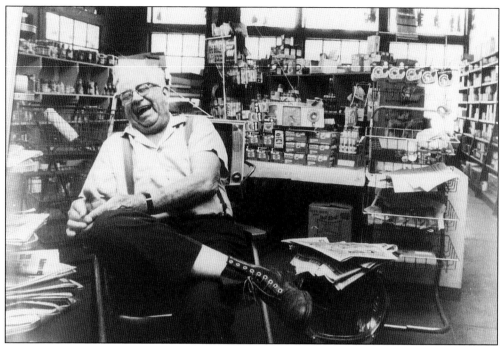

Dewet Adair is pictured with the Adair family's second store as it appeared in 1980. (Courtesy Palm Harbor Historical Society.)

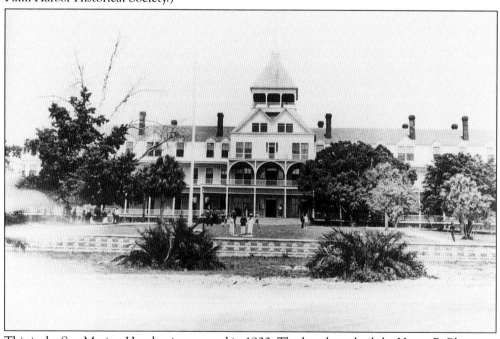

This is the San Marino Hotel as it appeared in 1900. The hotel was built by Henry B. Plant as a lure for business for his railroad. By 1902 the hotel had become the Florida Seminary and later became known as Southern College until 1921. After a fire and a hurricane ravaged the campus between 1921 and 1922, the remaining buildings became the South Florida Military Academy. (Courtesy Palm Harbor Historical Society.)

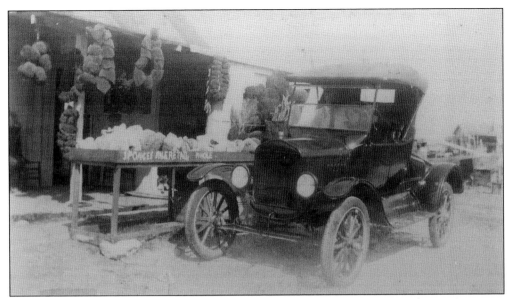

Henry Ford's ability to make automobiles affordable and numerous began to change American society, especially in the South. Large numbers of people began traveling for the first time, while earlier generations had been restricted to their local regions due to a lack of an efficient means of transportation. The world began to look a bit smaller for some folks. This Model T Ford belonged to W.B. Hill, c. 1918. (Courtesy Palm Harbor Historical Society.)

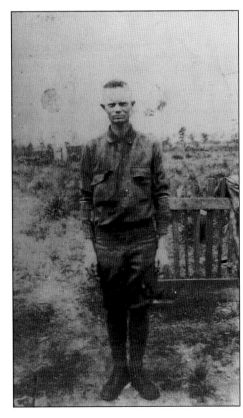

During World War I many people answered the call to volunteer, especially those from Palm Harbor. Here we see Eugene Hill in uniform. The photograph was taken in 1918. (Courtesy Palm Harbor Historical Society.)

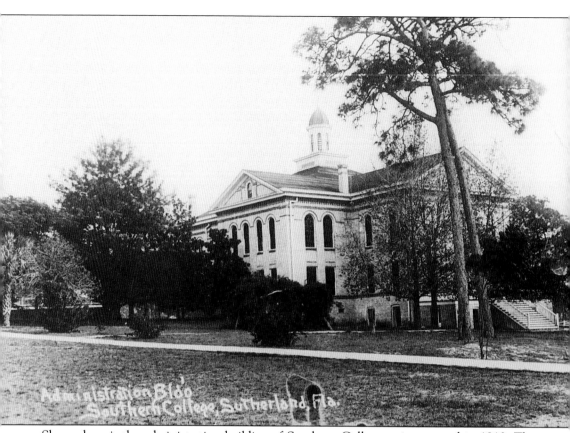

Shown here is the administration building of Southern College as it appeared in 1910. The building was constructed in 1904. (Courtesy Palm Harbor Historical Society.)

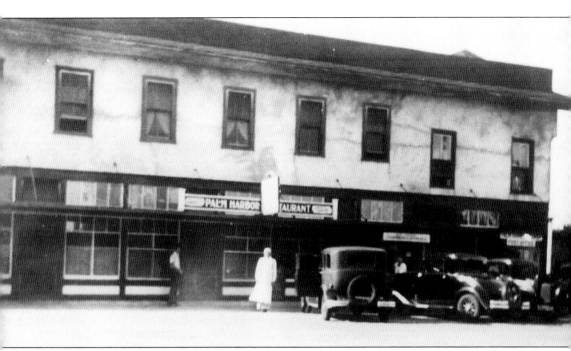

The Old Palm Harbor Restaurant and Bank of Commerce was built around 1890. The old bank became Adair's first grocery store (currently the Sutherland Cafe). The photograph dates to around 1933. The town's third post office was located here between 1923 and 1925. (Courtesy Palm Harbor Historical Society.)

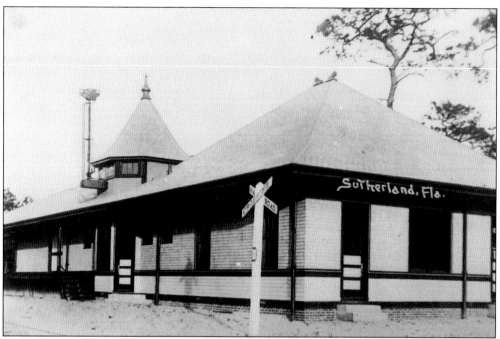

Before it became Palm Harbor, the community was known as Sutherland. This was the third depot that serviced the Orange Belt Railroad, c. 1917. (Courtesy Palm Harbor Historical Society.)

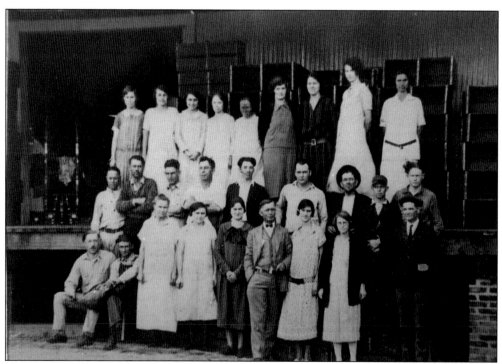

The Manatee Citrus Packing House crew is pictured here, c. 1923. (Courtesy Palm Harbor Historical Society.)

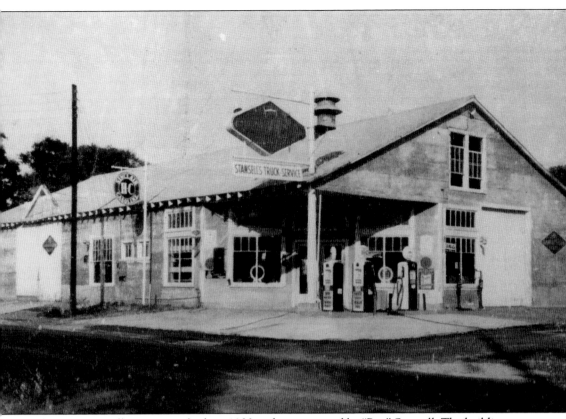

The H.L. Stansell Garage was built in 1933 and was operated by "Pop" Stansell. The building was still standing and serving as a gas station as of 1994. (Courtesy Palm Harbor Historical Society.)

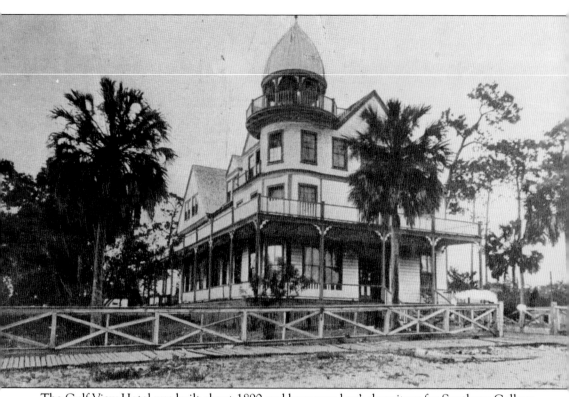

The Gulf View Hotel was built about 1890 and became a boy's dormitory for Southern College in 1902. The photograph dates to around 1912. (Courtesy Palm Harbor Historical Society.)

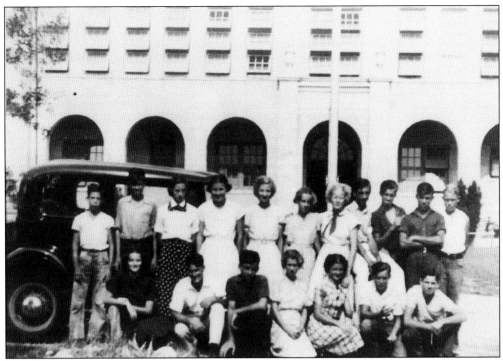

The Palm Harbor Junior High School was built in 1926. The graduating class of 1938 is pictured here. (Courtesy Palm Harbor Historical Society.)

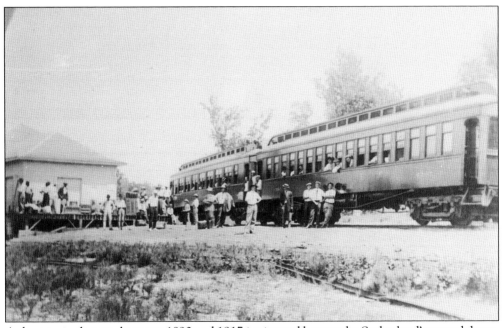

A short train that ran between 1890 and 1917 is pictured here at the Sutherland's second depot, c. 1912. (Courtesy Palm Harbor Historical Society.)

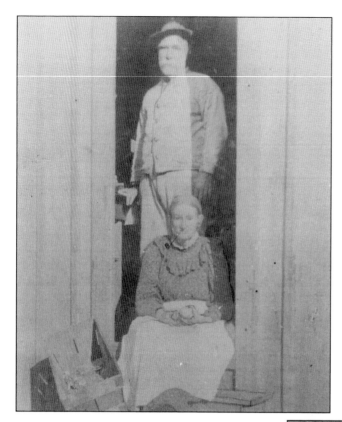

In 1864 William Lawrence Thompson (1832–1908), a farmer, brought his family from north Florida to a patch of forest about 3 miles south of Tarpon Springs. He homesteaded and cleared enough land to build a log cabin and raise crops and citrus. He is pictured here with his wife, Eliza (1832–1907.) (Courtesy Palm Harbor Historical Society.)

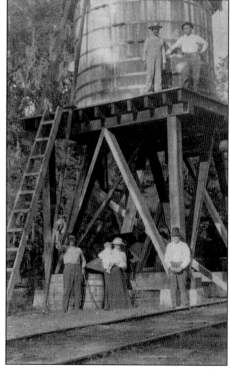

A water tank for the Orange Belt Railway is shown here, c. 1890. The tank provided water for the wood-burning locomotives that ran these tracks. (Courtesy Palm Harbor Historical Society.)

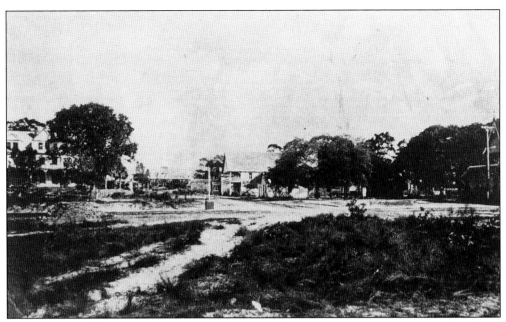

This is a view of Florida Avenue looking up to the college from the side of the railroad tracks in Sutherland, *c.* 1905. (Courtesy Palm Harbor Historical Society.)

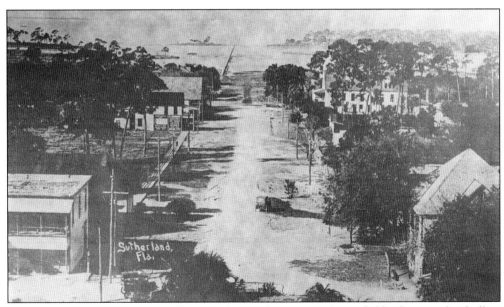

This is a view of Florida Avenue from Omaha Circle, *c.* 1910. A wooded bridge over the shallow water of Bay St. Joseph connected the west end of Florida Avenue with Pig Island, east of Hog Island, later renamed Honeymoon Island. In 1925 the town of Sutherland was renamed Palm Harbor. (Courtesy Palm Harbor Historical Society.)

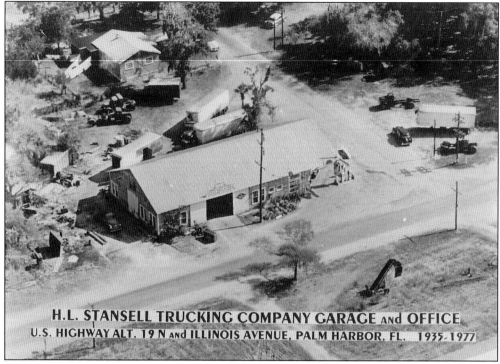

H.L. STANSELL TRUCKING COMPANY GARAGE and OFFICE
U.S. HIGHWAY ALT. 19 N and ILLINOIS AVENUE, PALM HARBOR, FL. 1935-1977

This is an aerial view of the H.L. Stansell Trucking Company Garage and Office on U.S. 19 and Illinois Avenue. (Courtesy Palm Harbor Historical Society.)

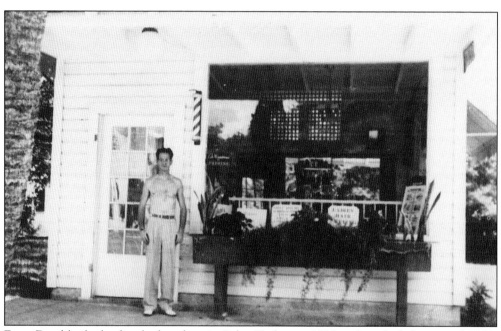

Emer Doud built the first barber shop in Palm Harbor in 1920 and worked there until 1954. Fred Wheeler, pictured here c. 1954, bought the barber shop from Emer Doud in 1954 and worked as a barber until he retired in 1974. (Courtesy Palm Harbor Historical Society.)

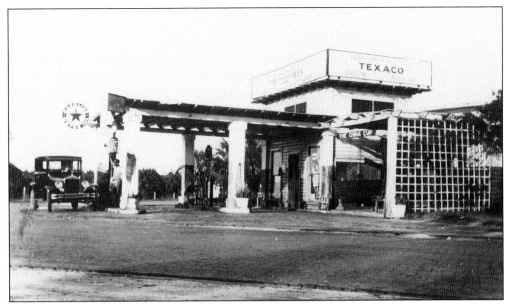

The Cross Roads Gas Station was built by Ed Bulloch in 1924, and was located on County Road 1 and Tampa Road. The station was torn down in 1976. (Courtesy Palm Harbor Historical Society.)

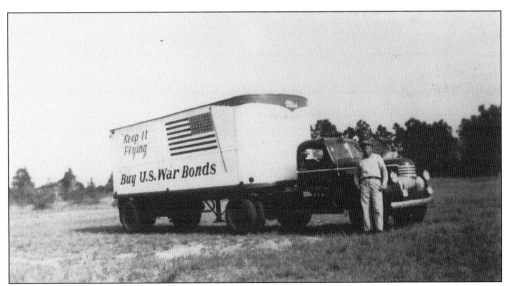

H.L. Stansell's 1941 Chevrolet truck was photographed being driven during World War II. Note the patriotic slogan painted on the side of the truck. Tom Holland, the driver, is pictured alongside the truck, c. 1943. (Courtesy Palm Harbor Historical Society.)

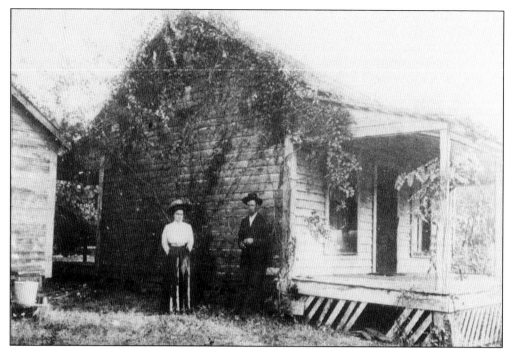

Early pioneer J.C. Craver (1849–1920) is pictured here with his niece, Florie Craver. The home was located at the northeast corner of Michigan Avenue and 12th Street. The photograph dates to around 1916. (Courtesy Palm Harbor Historical Society.)

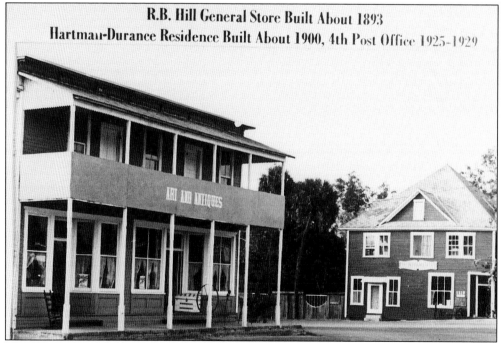

The R.B. Hill General Store was built about 1893. The nearby Hartman-Durance residence was built about 1900 and served as Palm Harbor's fourth post office from 1925 to 1929. (Courtesy Palm Harbor Historical Society.)

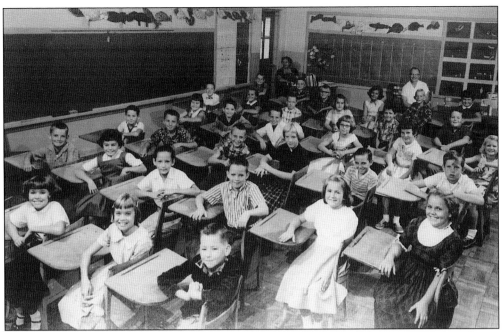

The fourth-grade students of Palm Harbor Junior High School had their picture taken during the school year of 1959–60. Mary (Mears) Dixon was the class's homeroom teacher and Milton A. Galbraith was the principal. (Courtesy Palm Harbor Historical Society.)

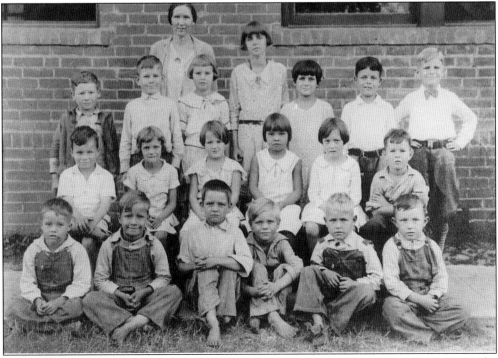

First and second graders of Curlew School are shown here, c. 1931. Eloise Thompson is the teacher. (Courtesy Palm Harbor Historical Society.)

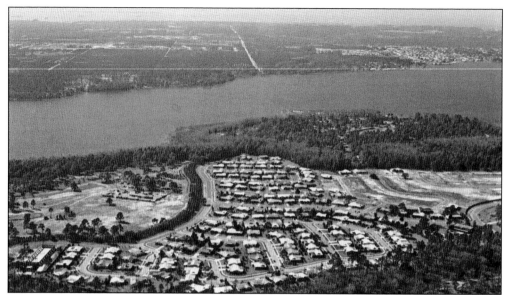

From the 1960s through the 1980s, Pinellas County grew with new subdivisions from Gulfport to Tarpon Springs. Palm Harbor also prospered from the growth during those years. Pictured is the Anchorage development as it appeared in the early 1970s. (Courtesy A.M. de Quesada Collection.)

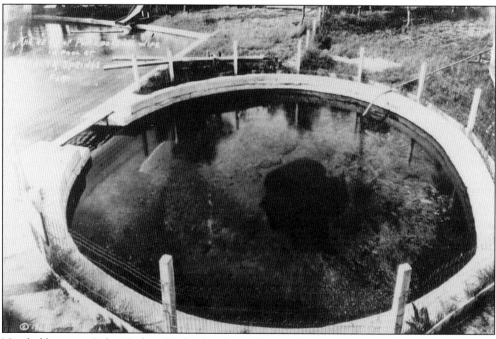

Nestled between Palm Harbor (Sutherland) and Tarpon Springs lies a small community called Ozona. In this community, a water outlet called Wall Springs existed. The natural spring has a constant temperature of 74 degrees and was believed to have had a medicinal effect on various ailments. This photograph, taken in 1917, shows the natural formation in the shape of a women's head made out of limestone rock in the center of the springs. (Courtesy Dunedin Historical Museum.)

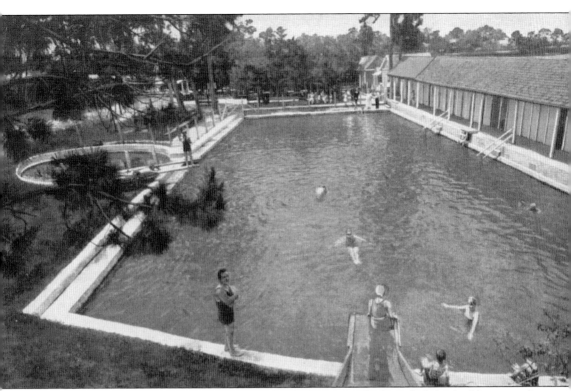

By the 1920s, Wall Springs had become a family business which included a bathhouse and swimming pool facility. The 30-foot-wide pool was supplied with water by a break in the spring's barrier wall. The spring reportedly pumped out 4 million gallons of water a day. The health complex was used until the mid-1960s, when it was closed because of the high cost of liability insurance incurred by the Cullen family. Recently, Pinellas County officials have approved plans to renovate the springs area and build a picnic and park facility at the site. (Courtesy Dunedin Historical Museum.)

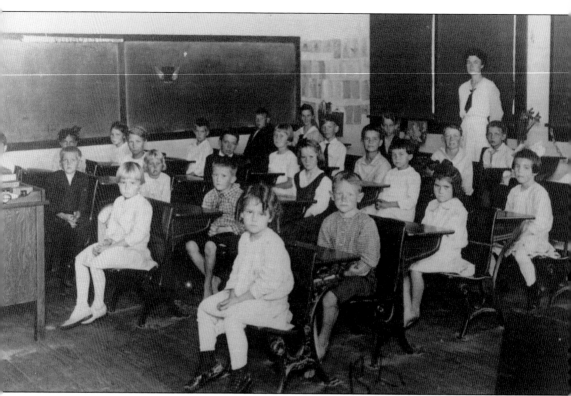

The early community of Ozona had its own elementary school for its residents. Here a photograph taken around 1919 shows the interior view of the classroom with its students and their teacher, Miss Lane. Today, the Old Wall Spring school in Ozona is now the Olde Schoolhouse Restaurant on Alternate U.S. 19. (Courtesy Palm Harbor Historical Society.)

Six

CLEARWATER,
THE GULF BEACHES, AND
NEARBY COMMUNITIES

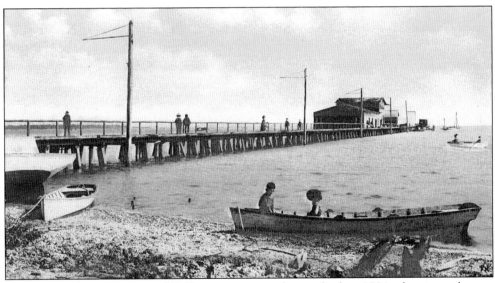

The modern-day community of Gulfport can trace its history back to 1884, when it was known as Disston City. However, when the post office opened that same year another Florida town was called Diston and therefore the local post office was called Bonifacio. At the turn of the 19th century a large influx of Union Civil War veterans began calling this small Southern community home and in 1906 the town was renamed Veteran's City. In 1910, the town name was again changed, this time to Gulfport. The image seen here is of the Gulf Casino dock, c. 1906. (Courtesy A.M. de Quesada Collection.)

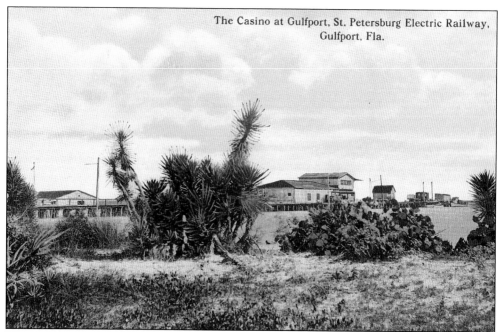

The Casino at Gulfport, St. Petersburg Electric Railway, Gulfport, Fla.

The casino at Gulfport brought prosperity to the small community. The St. Petersburg Transportation Company (also known as the St. Petersburg Electric Railway), owned by F.A. Davis, extended its streetcar line to Gulfport in 1905. Travelers could now reach Pass-a-Grille by riding the line to Gulfport's city dock and taking a boat across the bay. (Courtesy A.M. de Quesada Collection.)

The Rolyat Hotel, nestled between St. Petersburg and Gulfport, was built in 1925 by Jack Taylor. The hotel's name is actually "Taylor" spelled backwards. With the boom of the 1920s crashing all around the country, the hotel was sold in 1929 to pay off debts incurred by the Taylors. (Courtesy A.M. de Quesada Collection.)

In 1929, Colonel Walter B. Mendels bought the former Rolyat Hotel and turned it into the Florida Military Academy, which operated here until 1951, when the Stetson Law School purchased the property for $200,000, remodeled the structure, and reopened it officially on September 20, 1954. (Courtesy A.M. de Quesada Collection.)

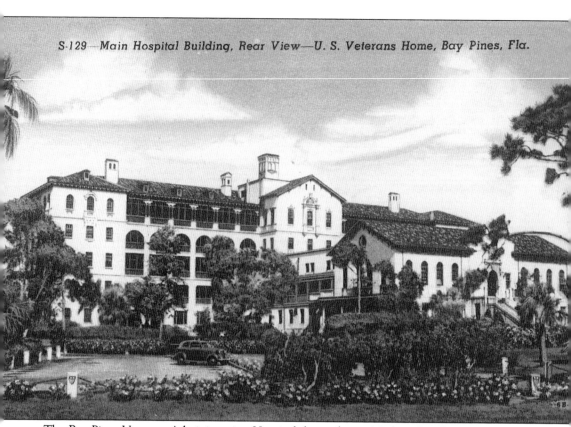

The Bay Pines Veterans Administration Hospital, located near Madiera Beach, was built in the Depression and provided jobs for the local unemployed. This was one of many government projects that benefited Pinellas County during the Depression. (Courtesy A.M. de Quesada Collection.)

The Bay Pines VA Hospital maintains a cemetery in which veterans of conflicts from the Civil War to the present are interred. A nearby veteran's park also complements the entire Bay Pines complex. (Courtesy A.M. de Quesada Collection.)

The Seminole Methodist Church was organized in 1890 and serves the Seminole, Bay Pines, and Gulf Beaches areas. This sanctuary, completed in 1957, is one of four buildings on a 5-acre site. (Courtesy A.M. de Quesada Collection.)

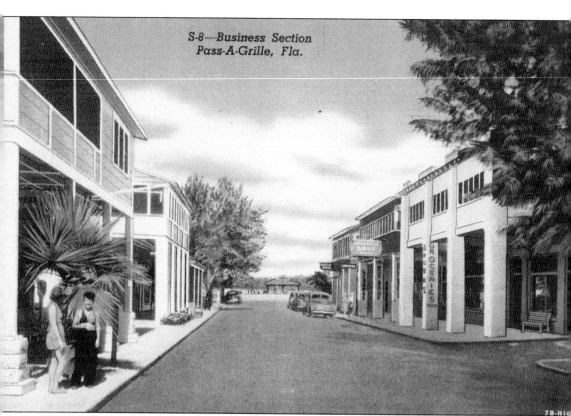

S-8—Business Section
Pass-A-Grille, Fla.

Zephaniah Phillips, a Civil War veteran, platted a section of land called Pass-a-Grille in March 1890. Pictured here is the business section of the small beachside community. (Courtesy A.M. de Quesada Collection.)

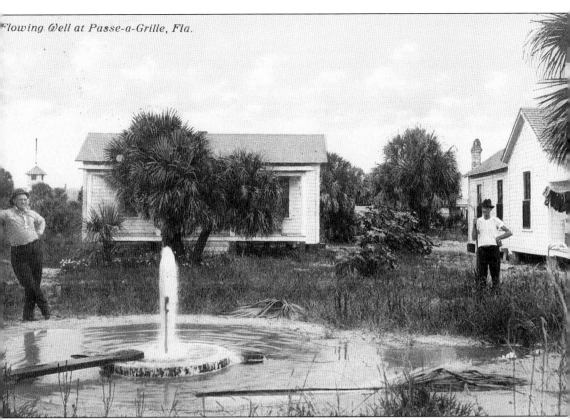
Flowing Well at Passe-a-Grille, Fla.

Many small communities in Florida, especially those located on barrier islands, were built around a freshwater source that came from underground artesian wells, such as this well from Pass-a-Grille. (Courtesy A.M. de Quesada Collection.)

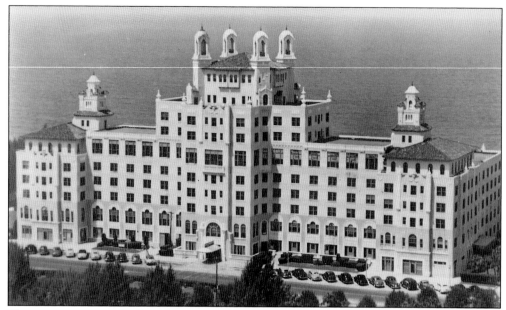

The construction on the Don Cesar Hotel began in 1925 and, due to financial difficulties, took three years to complete. During World War II the hotel was converted to a hospital for returning wounded airmen from Europe. Because of the large number of airmen associated with the hospital it was commonly nicknamed the "Flak Hotel." After the war the building served as a Veterans Administration Hospital, but in recent decades it reverted back to its original role as a hotel. (Courtesy A.M. de Quesada Collection.)

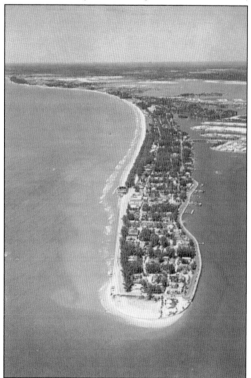

This is an aerial view of the southernmost tip of Pass-a-Grille Beach, where Boca Ciega Bay joins the Gulf of Mexico. During World War II the 252nd Coast Artillery took possession of the community from Third Avenue down to the pass. After the war the area reverted back to civilian control. (Courtesy A.M. de Quesada Collection.)

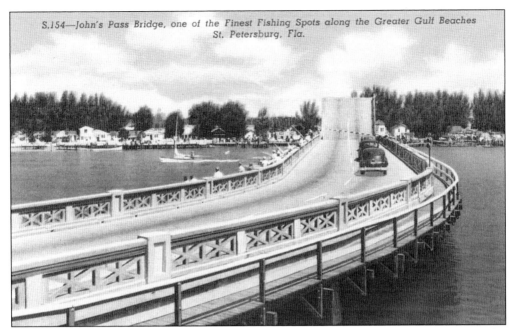

In 1927, when the new bridges connected the Gulf Beaches at Blind Pass and John's Pass, the communities of St. Petersburg Beach, Treasure Island, and Madiera Beach came into existence. Pictured here is the John's Pass Bridge as it appeared during the late 1930s. (Courtesy A.M. de Quesada Collection.)

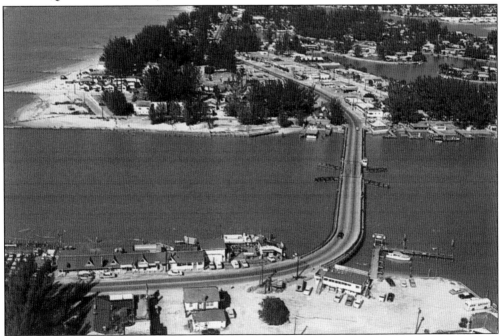

Shown here is an aerial view of John's Pass on Treasure Isle looking north, toward Madiera Beach, near St. Petersburg. The photograph dates to the early 1960s. Today condominiums and strip centers have replaced many of the beach cottages and small businesses. (Courtesy A.M. de Quesada Collection.)

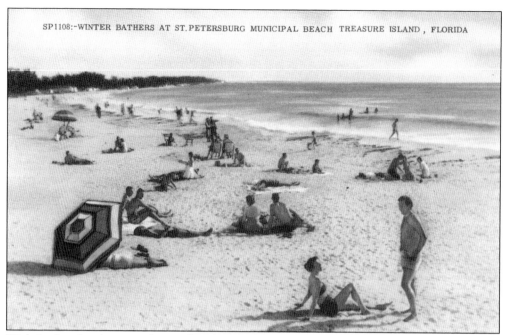

With further development during the 1920s, communities such as St. Petersburg Beach sprang up. Here, winter bathers from northern states are seen enjoying the Florida sun and water. (Courtesy A.M. de Quesada Collection.)

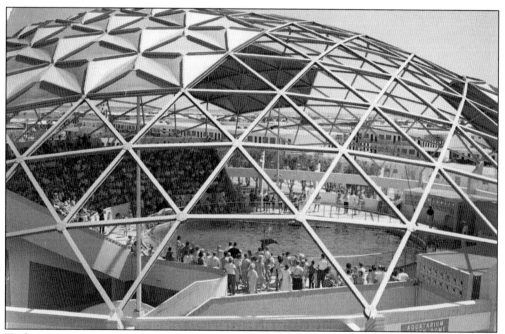

To lure more tourists to the area attractions were set up along the beaches, such as the Aquatarium in St. Petersburg Beach, c. 1965. Regular shows with porpoises, sea lions, and whales entertained the crowds in the days before Busch Gardens, Disney World, and Sea World. (Courtesy A.M. de Quesada Collection.)

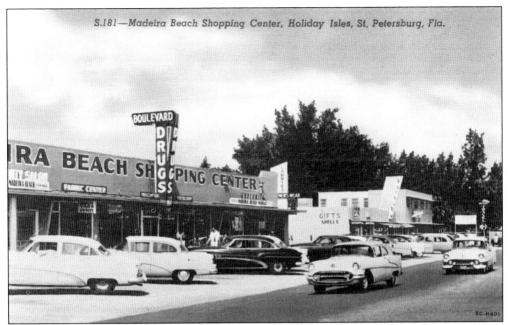

With the establishment of a system of roads and bridges along the Gulf Beaches in the 1920s and 1930s, businesses began to sprout along the roads. By the 1950s many portions of the beach communities had been commercialized, as this scene in Madiera Beach shows. (Courtesy A.M. de Quesada Collection.)

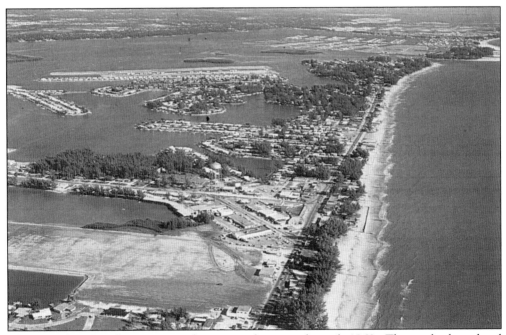

This is Madiera Beach as it appeared in an aerial view in the early 1960s. The newly cleared and graded section just below the shopping area would soon become the new Municipal Center. John's Pass (upper right) leads into Boca Ciega Bay from the Gulf of Mexico. (Courtesy A.M. de Quesada Collection.)

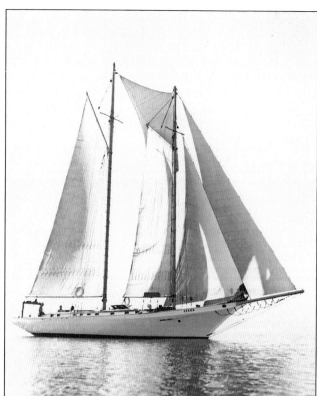

This sailboat is an example of the various types of sailing and motor vessels that sailed along the coasts of the beach communities in Pinellas County. (Courtesy A.M. de Quesada Collection.)

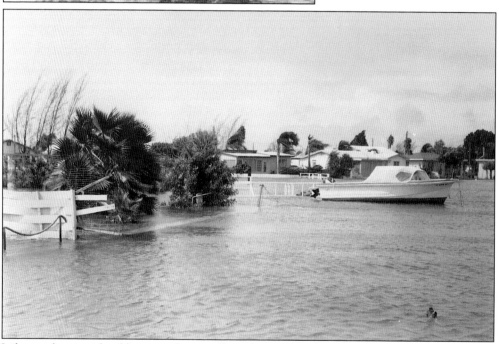

Life on a barrier island has its risks as well, such as tropical storms and hurricanes. Here is a flooded neighborhood in Madiera Beach after a tropical storm, c. 1963. (Courtesy A.M. de Quesada Collection.)

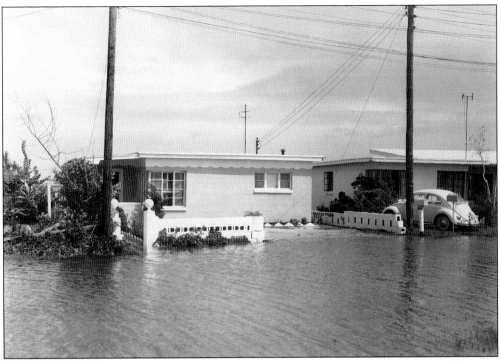

Here is another scene of the damage done by a passing tropical storm. To this day the communities along the beaches are still vulnerable to storms. (Courtesy A.M. de Quesada Collection.)

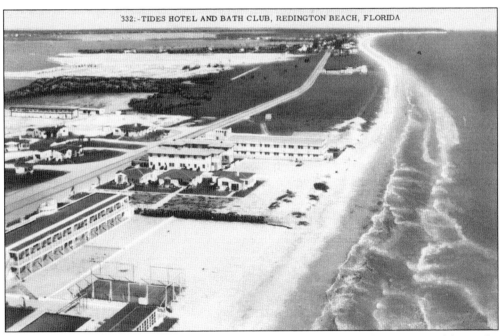

332:-TIDES HOTEL AND BATH CLUB, REDINGTON BEACH, FLORIDA

Shown here is a view of the Tides Hotel and Bath Club in Redington Beach as it appeared during the 1940s. There was plenty of undeveloped land around. (Courtesy A.M. de Quesada Collection.)

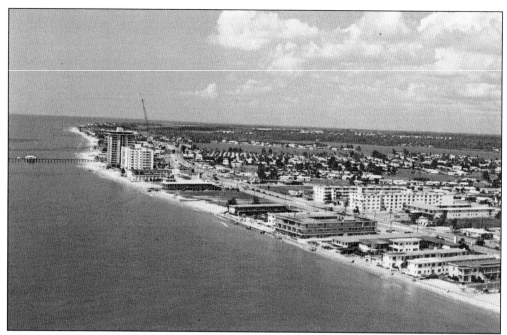

By the 1970s the Tides Hotel would be surrounded by a sea of concrete and asphalt. (Courtesy A.M. de Quesada Collection.)

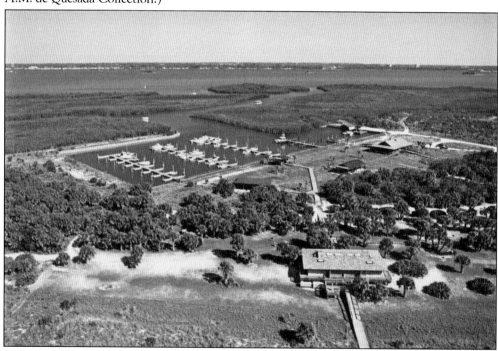

With rapid development literally going unchecked along the beaches during the 1970s and 1980s, some islands escaped by becoming state refuges or parks. Such was the case with Caladesi Island State Park. Visitors can reach the island only by private boat or ferry and can enjoy the nature trails, shelling on over 2 miles of white sand beaches, swimming, fishing, or just relaxing under the Florida sun. (Courtesy A.M. de Quesada Collection.)

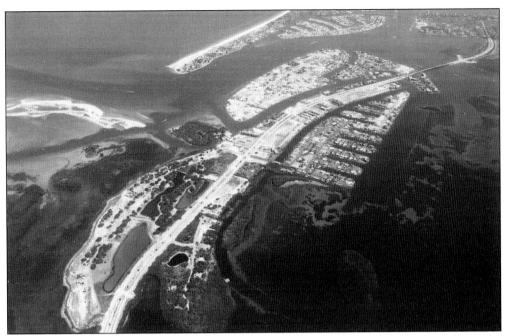

Tierra Verde can trace its history to the Native Americans who once built mounds on the island. Today it is a popular resort community. (Courtesy A.M. de Quesada Collection.)

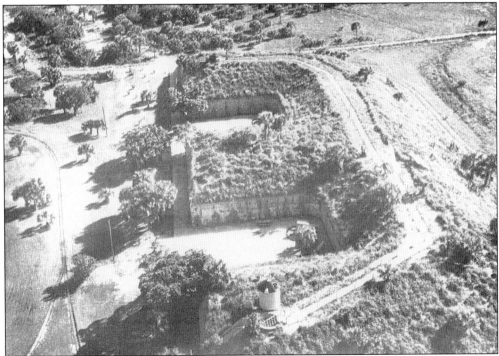

This is Fort DeSoto's Battery Laidley as it appeared during the 1940s. Forts Dade (Egmont Key) and DeSoto (Mullet Key) began their careers at the outset of the Spanish-American War and continued service well into World War II. Today, Fort DeSoto is a Pinellas County Park while Fort Dade is a state park. (Courtesy St. Petersburg Historical Museum.)

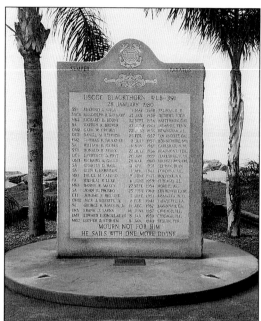

Tragedy would occur twice at the Skyway Bridge. In January 1980 the USCGC *Blackthorn*, a buoy tender, was rammed by the freighter *Capricorn*. The collision sank the *Blackthorn*, taking 23 men with her. The ship was later raised and resunk in the Gulf of Mexico, where it is a popular dive site today. Her ship's bell is on a temporary loan to the Veterans Memorial Museum in Tampa and is used as a shrine to those who lost their lives on that fateful night. This memorial is found along the causeway of the Sunshine Skyway Bridge. (Photograph by A.M. de Quesada.)

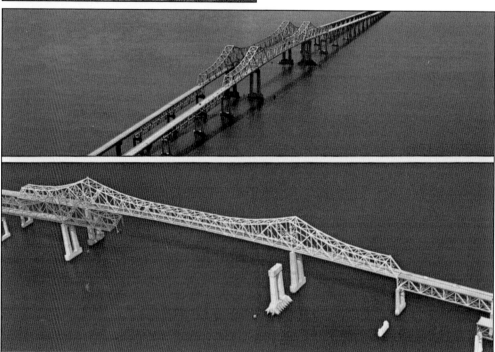

The Sunshine Skyway Bridge consisted of 11 miles of bridge and causeway crossing Tampa Bay from St. Petersburg and Bradenton. The second tragedy occurred when, after being struck several times before, on the morning of May 9, 1980, the bridge was struck by a freighter, knocking down the south-bound span. One bus and several cars went down with it, killing 34 people. Here is a before and after scene of the bridge. Today a new span has replaced the old bridges. The southbound bridge, though partially repaired since the accident, is now a popular fishing pier. (Courtesy A.M. de Quesada Collection.)

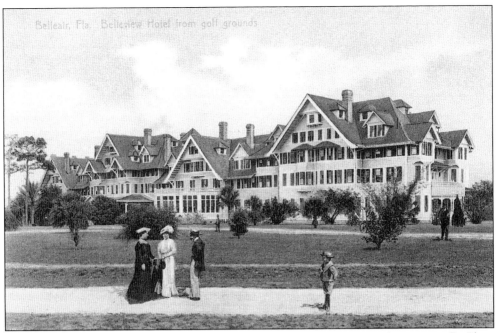

Belleair, located between Clearwater and Largo, came into existence when Henry B. Plant wanted to build his hotel in 1895. The idea was to wine and dine celebrities and influential businessmen at a fine hotel supported by one of Plant's railroads. The Belleview-Biltmore Hotel is shown here as it appeared from the golf course during the turn of the 19th century. (Courtesy A.M. de Quesada Collection.)

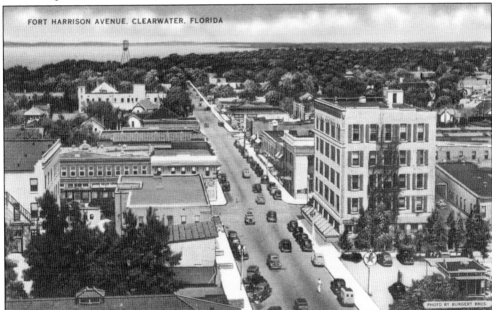

During the Second Seminole War, a temporary fort was constructed on the bluffs overlooking Clear Water Harbor. In the 1890s the area was named Clearwater Harbor and was officially simplified to just Clearwater in 1906. Pictured here is Ft. Harrison Avenue, in the heart of Clearwater. (Courtesy A.M. de Quesada Collection.)

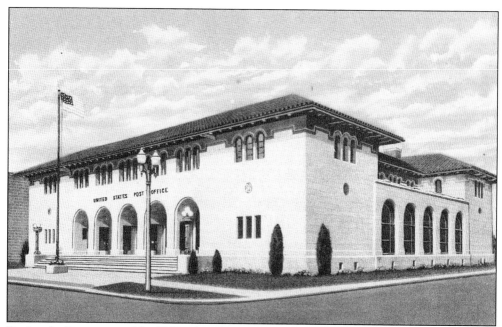

During the Depression of the 1930s, the Clearwater Post Office was a WPA project that provided some form of work for those unemployed. (Courtesy A.M. de Quesada Collection.)

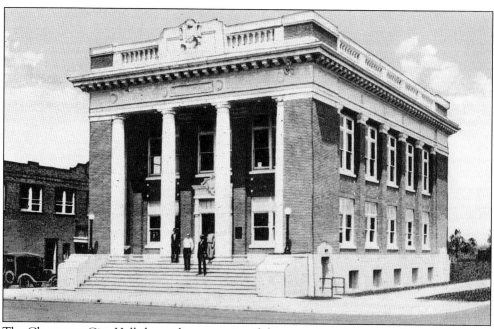

The Clearwater City Hall shows the prosperity of the town since becoming the county seat of Pinellas County, c. 1920. (Courtesy A.M. de Quesada Collection.)

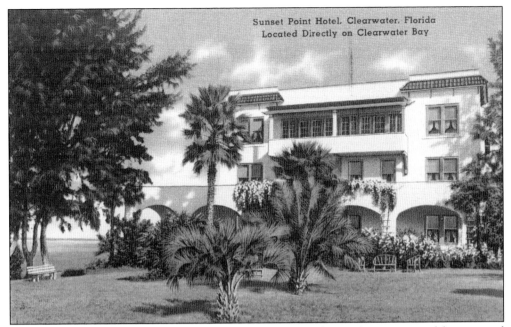

By the 1920s Florida had become a haven for tourists from the northern states and from around the world, a practice that still continues to this day. The Sunset Point Hotel was one such place out of many that catered to the tourists, or "Snow Birds," and provided many a serene view of Clearwater Bay, *c.* 1940s. (Courtesy A.M. de Quesada Collection.)

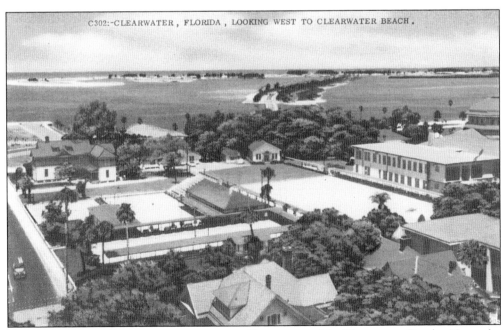

C302:-CLEARWATER, FLORIDA, LOOKING WEST TO CLEARWATER BEACH.

Shown here is the causeway connecting Clearwater with Clearwater Beach. Note the shuffleboard facility in the center portion of the photograph, *c.* 1940s. (Courtesy A.M. de Quesada Collection.)

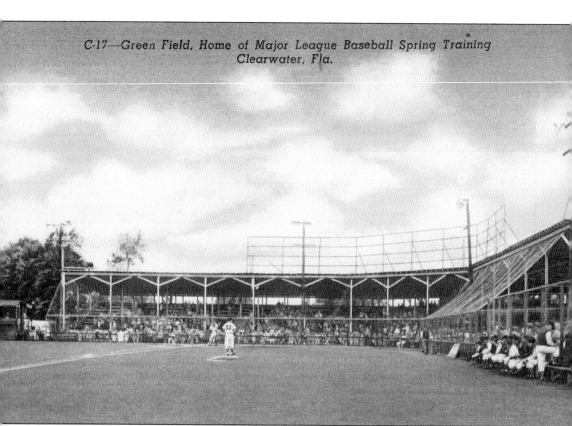

Many major league baseball teams made the various Florida communities their winter home
and spring training campgrounds. Pictured here is Green Field during an exhibition game
between major league baseball clubs from nearby winter training headquarters, c. 1940s.
(Courtesy Dunedin Historical Museum.)

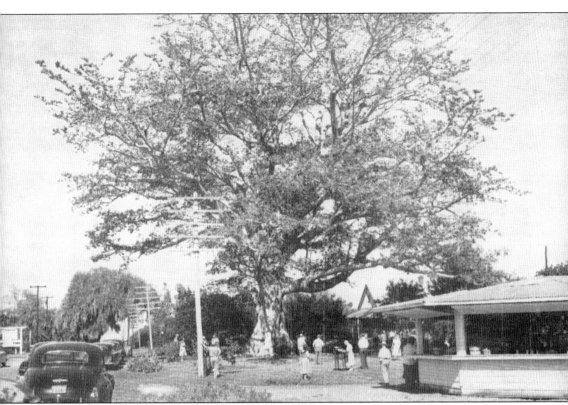

The 400-year-old kapok tree located on North Haines Road was a favorite Clearwater landmark for many years. A popular restaurant was built around the tree and was a famous tourist spot. The tree is still there as well as the restaurant building, which is currently serving as a music store. (Courtesy Dunedin Historical Museum.)

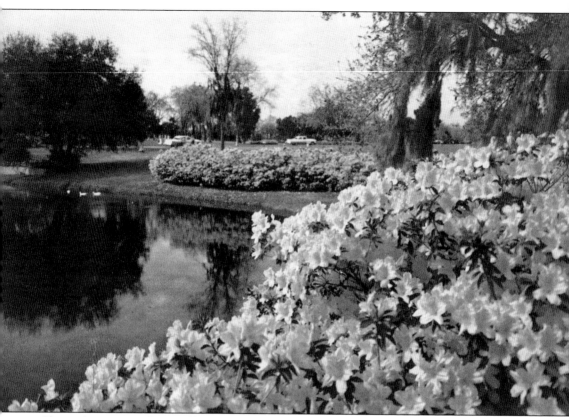

Shown here are azaleas in bloom at Sylvan Abbey between Clearwater and Safety Harbor. Sylvan Abbey is a cemetery that dates back to the early settlers who made the Pinellas Peninsula their home, c. 1965. (Courtesy A.M. de Quesada Collection.)

Seven

SAINT PETERSBURG

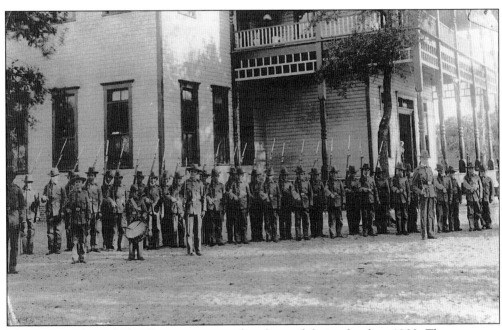

The St. Petersburg Cadet Corps are pictured in front of their school, c. 1900. The corps was outfitted by B.H. Tomlinson from surplus muskets and uniforms from the Spanish-American War. (Courtesy St. Petersburg Historical Museum.)

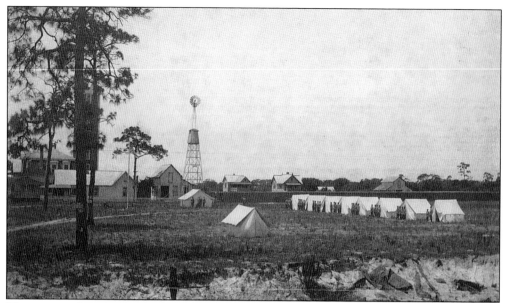

This is an early encampment scene of the St. Petersburg Cadet Corps on the school grounds. (Courtesy St. Petersburg Historical Museum.)

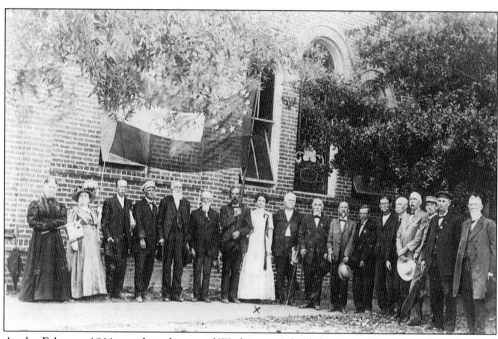

At the February 1911 parade in honor of Washington's birthday in St. Petersburg, FL, the local Grand Army of the Republic post, a Union Civil War veteran's organization, banned the Confederate veterans of Camp Zollicoffer from marching in the parade because of fears that the old "rebels" might display their banners. The event became quite uncomfortable for local politicians in the years following the debacle. The marshal that ordered the Confederate veterans to furl their flag later resigned and left the city under heavy pressure by the public. Seen here are those members of Camp Zollicoffer. (Courtesy St. Petersburg Historical Museum.)

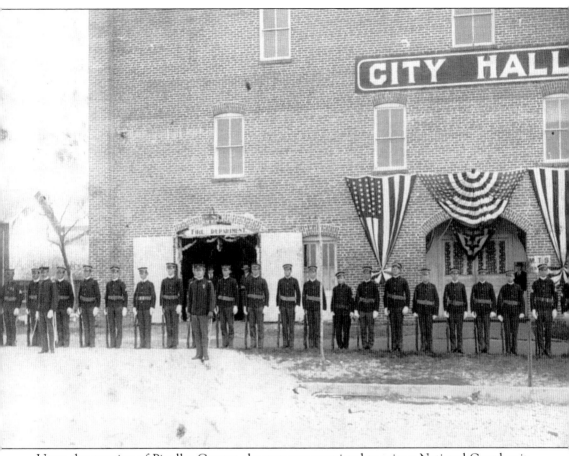

Upon the creation of Pinellas County, the area was permitted to raise a National Guard unit. Pictured are members of the Pinellas County Guards in front of the St. Petersburg City Hall. In 1911 many state troops were federalized and therefore a name change occurred, from Florida State Troops to Florida National Guard. (Courtesy St. Petersburg Historical Museum.)

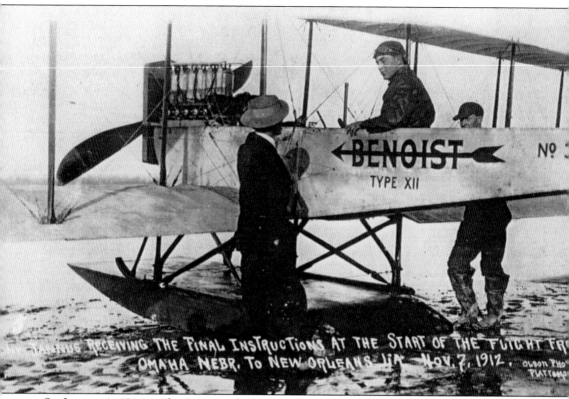

TANNUS RECEIVING THE FINAL INSTRUCTIONS AT THE START OF THE FLIGHT FR
OMAHA NEBR. TO NEW ORLEANS LA — NOV. 7, 1912. OLSON PHO
PLATTSMO

On January 1, 1914, a "first" occurred when Anthony "Tony" Habersack Jannus made the first commercial flight in the world from St. Petersburg to Tampa. A working replica of his plane, the *Benoist*, hangs in the gallery of the St. Petersburg Historical Museum. This photograph showing Jannus in the cockpit of the *Benoist* dates to 1912. (Courtesy A.M. de Quesada Collection.)

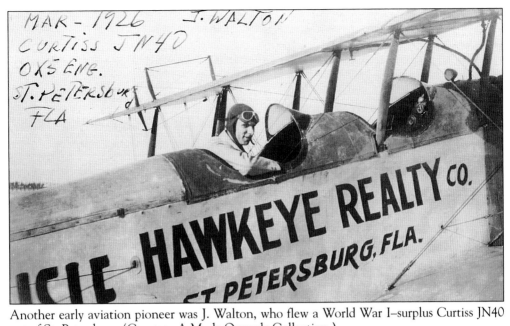

MAR - 1926 J. WALTON
CURTISS JN40
OX5 ENG.
ST. PETERSBURG
FLA

Another early aviation pioneer was J. Walton, who flew a World War I–surplus Curtiss JN40 out of St. Petersburg. (Courtesy A.M. de Quesada Collection.)

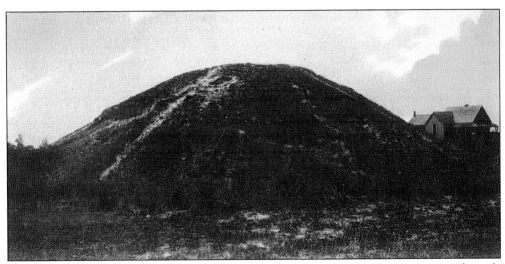

Throughout southern Pinellas there are dozens of prehistoric Native American mounds made from seashells. Aside from St. Petersburg there were other mounds at Safety Harbor, Weedon Island, Tierra Verde, and Gulfport. This mound was located on the grounds of the Bayfront Medical Center. In the 1920s local paving contractors used the shell from the mound on the nearby streets. (Courtesy A.M. de Quesada Collection.)

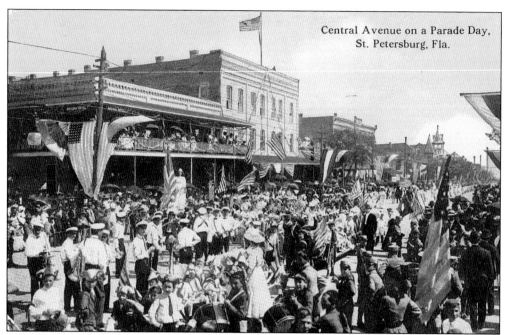

Central Avenue was the heart of St. Petersburg, where events of all types took place throughout the year. Here a parade is marching through town, c. 1900. (Courtesy A.M. de Quesada Collection.)

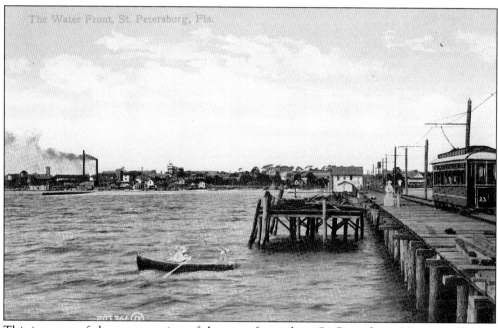

The Water Front, St. Petersburg, Fla.

This is a turn-of-the-century view of the waterfront along St. Petersburg. Note a trolley car moving up the recreation pier that connected with Central Avenue. (Courtesy A.M. de Quesada Collection.)

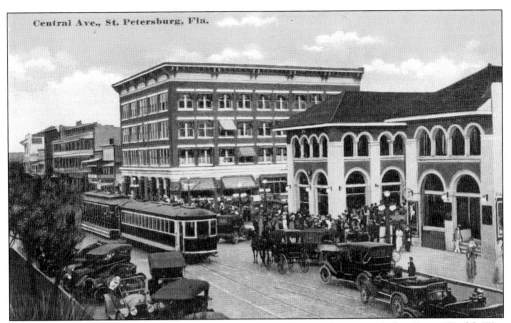

Central Ave., St. Petersburg, Fla.

Shown here is another view of Central Avenue during the era of the First World War (1914–1919). (Courtesy A.M. de Quesada Collection.)

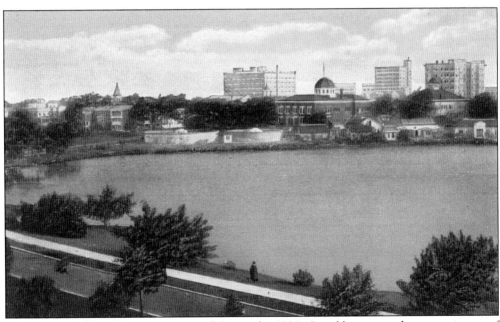

Mirror Lake is shown here as it appeared during the 1920s. Local lore states that a contingent of troops from Tampa guarded this water source from potential Spanish agents, who, it was feared, were going to attempt to poison it during the Spanish-American War. (Courtesy A.M. de Quesada Collection.)

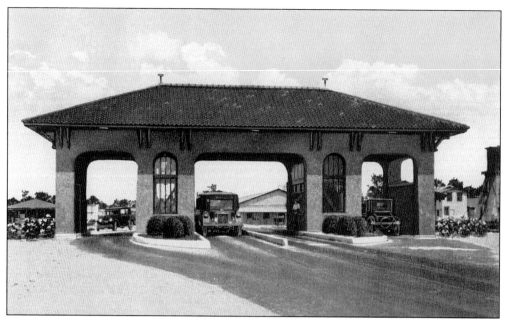

The Gandy Bridge connected Tampa with St. Petersburg. Construction began in 1922 and the bridge was completed in 1924. Pictured is one of the toll stations that led to the Gandy Bridge. (Courtesy A.M. de Quesada Collection.)

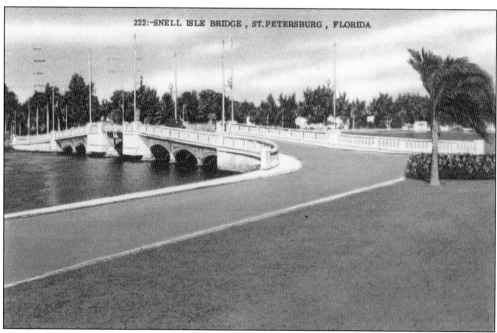

Snell Isle opened in October 1925. The subdivision was the brainchild of C. Perry Snell. Snell completed his project on the isle despite financial setbacks. Eventually he sold his mansion on the isle to Wally Bishop, famed cartoonist of *Mugs and Skeeter*. (Courtesy A.M. de Quesada Collection.)

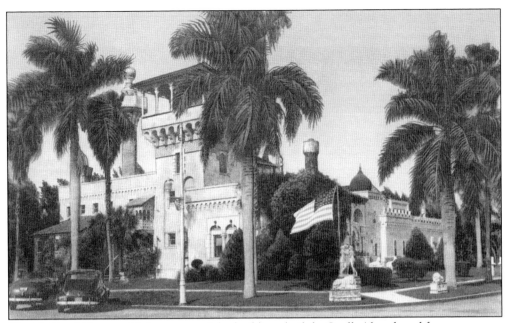

The Golf and Country Club was one of the buildings built by Snell. Abandoned for many years, in recent years the building was restored and it is now a part of the Vinoy Hotel. (Courtesy A.M. de Quesada Collection.)

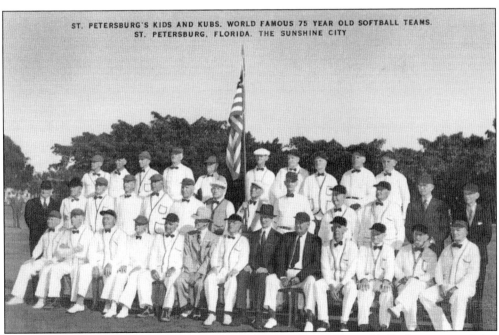

St. Petersburg's Kids and Kubs is world famous for its 75-and-older softball players, a tradition going back to the first half of the 20th century. (Courtesy A.M. de Quesada Collection.)

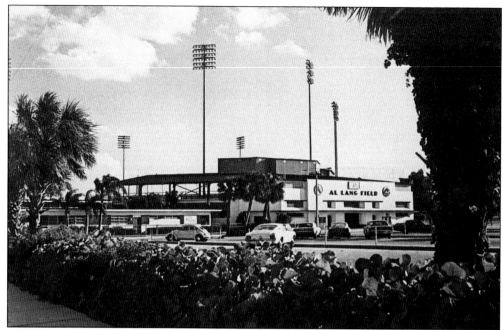

Al Lang Field served as the winter home of the St. Louis Cardinals, New York Mets, and St. Petersburg Cardinals. In 1996 St. Petersburg received its major league baseball team, the Tampa Bay Devil Rays, and renovated the old Thunderdome, now Tropicana Field. The team's inaugural season began in 1998. This photograph of Al Lang Field dates to about 1972. (Courtesy A.M. de Quesada Collection.)

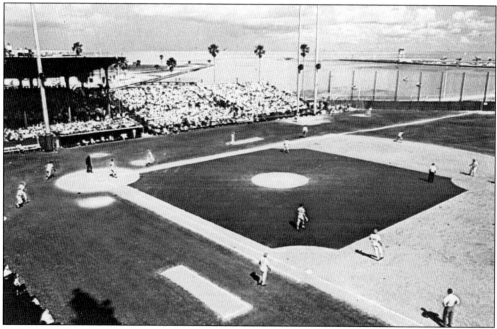

Al Lang Field is situated next to the Bayfront Center. In the distance to the right are the runways of Albert Whitted Airport. (Courtesy A.M. de Quesada Collection.)

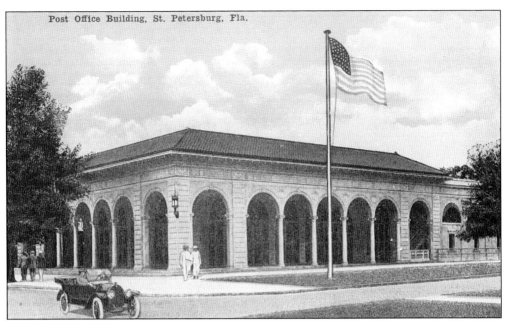

This is the St. Petersburg Post Office as it appeared in the 1920s in downtown. (Courtesy A.M. de Quesada Collection.)

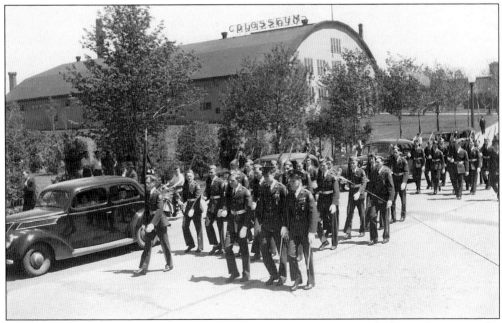

A detachment of the Civilian Conservation Corps was photographed marching past the St. Petersburg Colosseum. The CCC was a peacetime organization created by President Roosevelt as a way of providing employment during the economic depression of the 1930s. With military-style structure and training, it was an easy transition for its members to join the armed forces when war broke out. (Courtesy A. M. de Quesada Collection.)

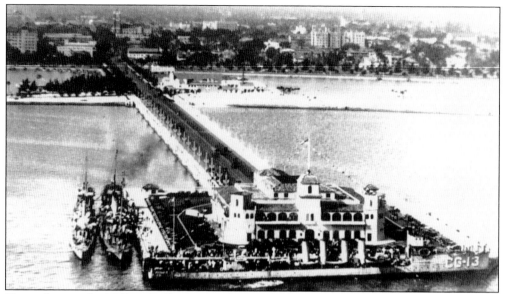

Shown here is the Million Dollar Pier and a peaceful St. Petersburg skyline as it appeared in 1933. Note the Coast Guard vessels moored alongside the structure. In 1927 the Coast Guard opened a facility at nearby Bayboro Harbor. (Courtesy St. Petersburg Historical Society.)

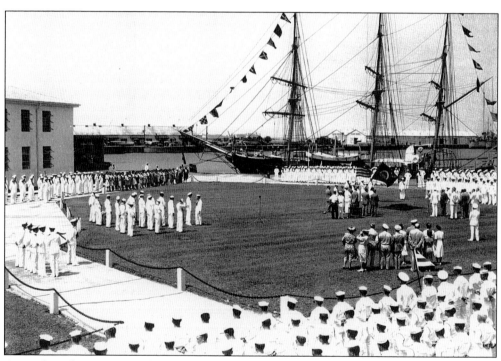

Across from the Coast Guard station is the United States Maritime Service Training Station. The Coast Guard established the installation in 1939 to train merchant seamen. As the installation grew with the outbreak of war, it was transferred to the USMS in 1943. During World War II, more than 25,000 recruits were trained at the St. Petersburg facility. Note the USMS Training ship *American Seaman* in the background. (Courtesy St. Petersburg Historical Society.)

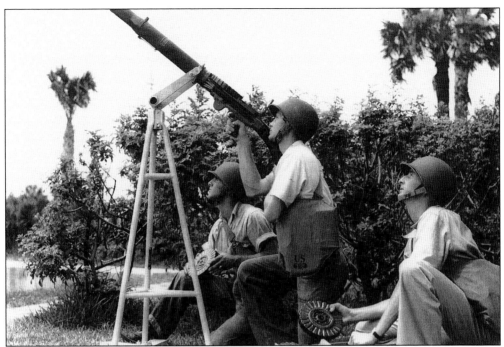

Here, merchant seamen practice firing a World War I-vintage Lewis Machine Gun somewhere near St. Petersburg during the Second World War. (Courtesy St. Petersburg Historical Society.)

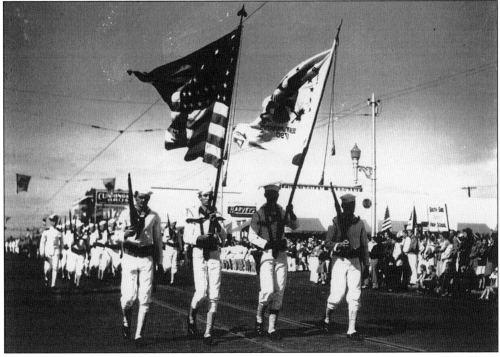

Coast Guardsmen parade down a St. Petersburg street during the war. Scenes such as these were common place in many Bay area towns on patriotic holidays. (Courtesy St. Petersburg Historical Society.)

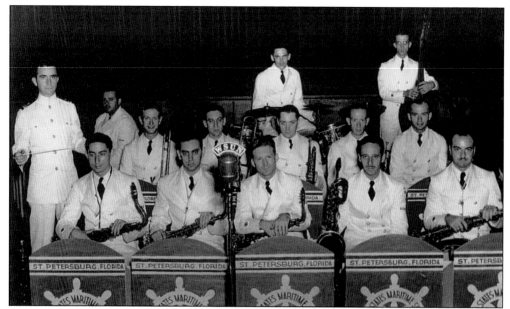

The 1940s was the era of the big bands, and it was only natural for the merchant seamen to have their own. Many military bands played for civilian as well as military audiences. Here the band is about to perform on the air with WSUN, a local St. Petersburg radio station. (Courtesy St. Petersburg Historical Society.)

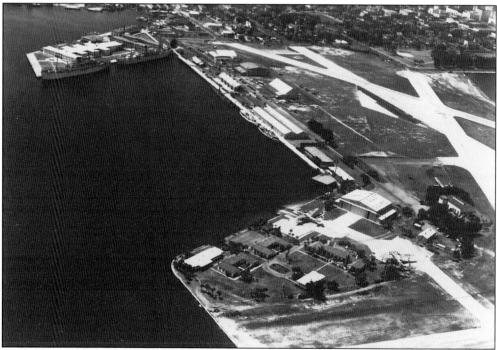

This is an aerial shot of Bayboro Harbor in St. Petersburg. Though taken in 1948, one can clearly see the CGAS and the nearby Maritime Service training station. Note the training ships and a World War II-era fleet type submarine moored along the naval warehouses. (Courtesy Tampa-Hillsborough County Public Library system.)

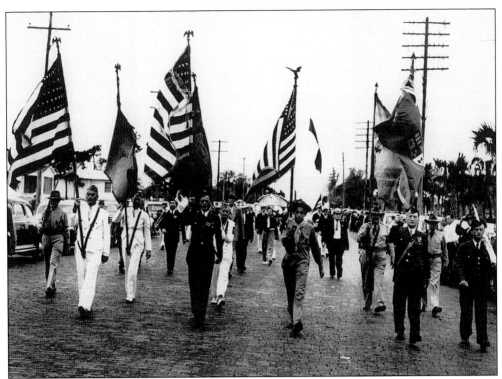

A patriotic parade of old veterans and Boy Scouts are pictured in the streets of St. Petersburg. Of interest are the different uniforms worn by these veteran's groups, such as the United Spanish War Veterans, American Legion, and British Veterans of the Great War. (Courtesy St. Petersburg Historical Society.)

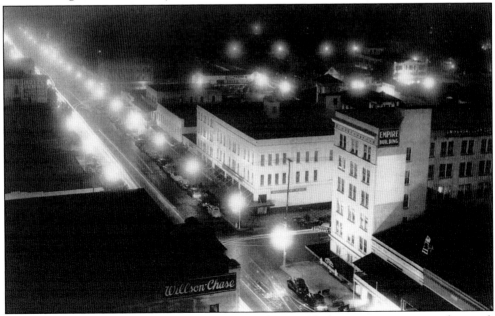

Shown here is wartime St. Petersburg. Later in the war blackout restrictions were lessened. (Courtesy St. Petersburg Historical Society.)

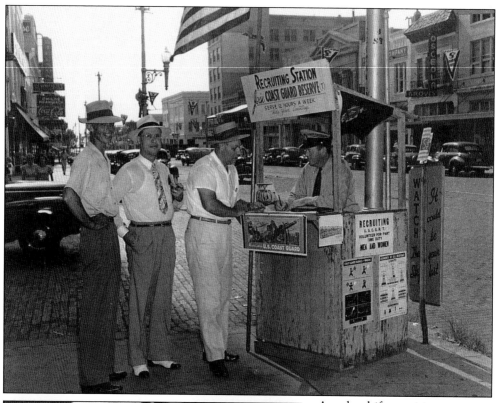

A make-shift recruiting station for the Coast Guard Reserve was located at a street corner on Central Avenue and Fourth Street in St. Petersburg. (Courtesy St. Petersburg Historical Society.)

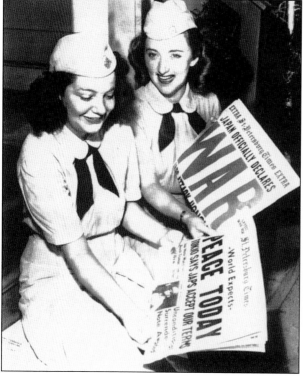

These two Navy nurses are holding newspapers of the *St. Petersburg Times* showing the declarations at the beginning and the end of war. (Courtesy St. Petersburg Historical Society.)

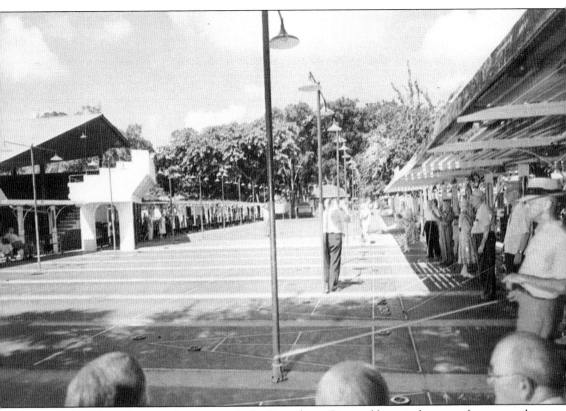

Shuffleboard is a very popular pastime in St. Petersburg. Pictured here is the central courts and grandstand of the St. Petersburg Shuffleboard Club. In the 1960s the club, located near Mirror Lake, was reputed to be one of the largest recreation centers in the world.

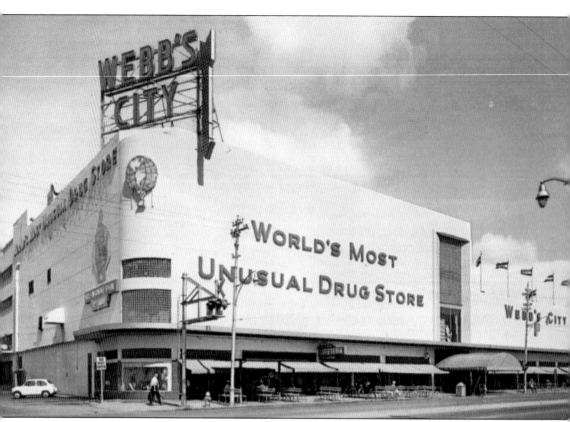

Webb's City was a popular shopping place for many in St. Petersburg. "Doc" J.E. Webb created a business that began as a pharmacy in the 1920s. He soon began branching out, adding groceries, gasoline, garden supplies, furniture, a beauty salon, a cafeteria, an ice cream shop, and a barber shop. The business was sold in 1972 and was closed down by 1975. It was located on 9th Street South. (Courtesy A. M. de Quesada Collection.)

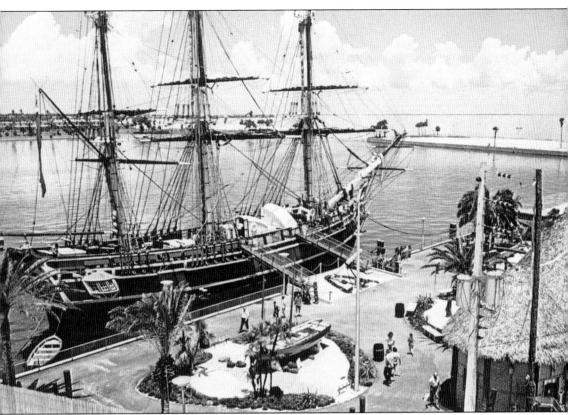

The famous sailing ship from the 1960 MGM film *Mutiny on the Bounty*, starring Marlon Brando, was Florida's first historical marine attraction and was exhibited at the Vinoy Yacht Basin, adjacent to the St. Petersburg Historical Museum. In the late 1980s the ship was purchased by Ted Turner and was later donated to a historical sailing ship society. The HMS *Bounty* now returns to St. Petersburg every year in late winter before sailing off to northern waters. (Courtesy A. M. de Quesada Collection.)

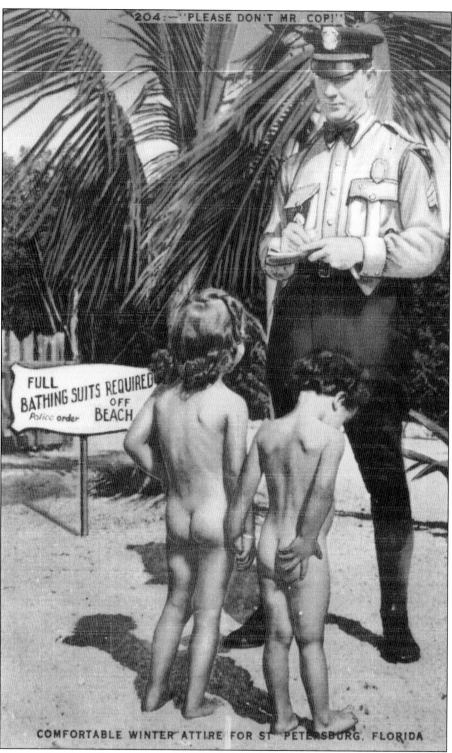

This is a parting shot of two youngsters learning the limits of a grownup world in the 1930s! (Courtesy A.M. de Quesada.)